The Solomon R. Guggenheim Museum, New York

# Italian Art Now:
# An American Perspective
# 1982 Exxon International
# Exhibition

by Diane Waldman

This exhibition is sponsored by Exxon Corporation

Published by The Solomon R. Guggenheim Foundation, New York, 1982

ISBN: 0-89207-033-1

Library of Congress Card Catalog Number: 81-86563

3

# Lenders to the Exhibition

Céline Bastian, Berlin

Heiner Bastian, Berlin

Sandro Chia

Enzo Cucchi

Barbara and Donald Jonas

Nino Longobardi

Roberta Maresca, Rome

Erich Marx, Berlin

Luigi Ontani

Giuseppe Penone

Vettor Pisani

Luciano Pistoi,Turin

Fabio Sargentini, Rome

Robert A. Rowan, Los Angeles

Gilberto Zorio

Musée National d'Art Moderne, Centre d'Art
et de Culture Georges Pompidou, Paris

Stedelijk Museum, Amsterdam

Salvatore Ala, Milan and New York

Galleria Lucio Amelio, Naples

Galerie Bischofberger AG, Zürich

Anthony d'Offay Gallery, London

Paul Maenz, Cologne

Sonnabend Gallery, New York

Gian Enzo Sperone, New York

Sperone Westwater Fischer, New York

# Table of Contents

# Preface and Acknowledgements

During the past decade the Guggenheim Museum has presented group shows of current art originating in The Netherlands, France, Germany, Britain and Spain. It is, therefore, very much within the framework of a consistent institutional commitment to recent art production on the one hand, and to the art scene beyond New York and the United States on the other, that we now offer a comparable selection of artists from Italy. In all these instances we have gratefully accepted guidance and suggestions from within the artists' country of origin, but have reserved for ourselves the final decisions regarding selection and organization of the exhibitions, thereby, of course, assuming full responsibility for both. In fact, decisions as well as responsibility have devolved upon the exhibition curator who, in the case of the current undertaking, is the Guggenheim's Deputy Director, Diane Waldman.

The system, if one may call it that, has not gone unchallenged, and advisors in the countries under consideration have protested at times that what is *their* art should be determined by *them*. On the surface this would not appear unreasonable, if only one could accept the idea that there exists both a definable contemporary national art and an individual capable of articulating it in the form of an exhibition. Since these premises seem far from established to us, we have felt obliged to limit our aspirations to the presentation of personal selections from abroad that are meant to reveal aspects of the art of a particular nation. That such qualifying remarks are usually ignored does not, we feel, invalidate them.

*Italian Art Now: An American Perspective, 1982 Exxon International Exhibition* thus represents a selection of artists, stringently restricted to no more than seven painters and sculptors, who, through the excellence of their current work, personify creative directions of particular interest to us. These directions include contemporary modes of Italian expressionism, whose roots are in the native *Pittura Metafisica*, in German Expressionism, in various international currents of fantastic art, as well as in postwar movements that occurred on both sides of the Atlantic (as exemplified by Sandro Chia, Enzo Cucchi and Nino Longobardi); a reductive style concerned with the articulation of space and conceptual aesthetics based in Italian *Arte Povera* and other minimalist movements (Giuseppe Penone and Gilberto Zorio); and a complex expression that has developed out of Performance Art (Luigi Ontani and Vettor Pisani). Whereas the seven artists represented here have been inspired by these wide-ranging precedents and share certain common characteristics, each transcends them to make his unique and personal contribution.

Despite such variety, indicative of a broad and non-dogmatic attitude on the selector's part, it would be contrary to our experience with shows of current international art if *Italian Art Now* were to be greeted with unanimous approval. Therefore, we anticipate, instead, lively controversy and challenge of our choices as more realistic and ultimately more rewarding reactions to our exhibition.

While our attention is initially focused upon the presentation of these seven Italian artists, first here and eventually at other American museums, our most important objective is the addition to the Guggenheim's permanent collection of one work by each participant in the exhibition. In providing funds for the acquisition of paintings and sculptures in addition to bearing the exhibition and catalogue costs, Exxon, our project's sponsor, retains and affirms its enviable position as the corporation that has most consistently and most generously aided contemporary art and living artists in the United States and abroad.

The Guggenheim Foundation's gratitude is herewith extended to Diane Waldman and her aides who staged the current *Exxon International Exhibition* and to Exxon, through the person of Leonard Fleischer, Senior Advisor to the Corporation's Arts Program, whose beneficial application of their policies to our needs is deeply appreciated.

Thomas M. Messer, *Director*
The Solomon R. Guggenheim Foundation

It would have been impossible to realize *Italian Art Now* without the support and cooperation of many individuals here as well as in Italy. Lisa Dennison, Assistant Curator at the Guggenheim Museum, has worked with me on all aspects of both exhibition and catalogue; her collaboration has been indispensable. I would also like to thank the many staff members at the Guggenheim Museum for their diligent efforts on behalf of this project. In particular, I wish to acknowledge Carol Fuerstein, Editor, for her intelligent editing of the catalogue and for seeing it through the presses; her assistant Cynthia Clark; Elizabeth Easton, Susan Taylor and Shara Wasserman. Gratitude is also due to the following individuals associated with galleries in the United States and abroad for their important assistance: Salvatore Ala and Caroline Martin, Lucio Amelio, Heiner Bastian, Bruno Bischofberger, Jim Corcoran, Mario Diacono, Anthony D'Offay and Anne Seymour, Mario Pieroni and Dora Stiefelmeier, Ileana Sonnabend and Antonio Homen, Gian Enzo Sperone, Angela Westwater, Konrad Fischer and Pier Luigi Pero; also Silvana Camoni of the Galleria Salvatore Ala and Julia M. Ernst of Sperone Westwater Fischer. Among the critics and friends who have been extraordinarily helpful are Giovanna Della Chiesa, Francesca Alinovi, Bruno Corà and Attanasio di Felice. My appreciation must be expressed to the generous lenders who have in a very tangible sense made the exhibition possible. Finally, my sincere thanks are extended to the artists themselves for their commitment and enthusiasm; working with them has been both enjoyable and rewarding.

DW

# Introduction

by Diane Waldman

Italian art today is as complex and compelling as Italy itself. If one were to visit, as this writer did, artists living and working in centers as diverse as Ancona, Turin, Milan, Pescara, Rome, Florence, Bologna and Naples, one would immediately become aware of the unique character of the *regioni* of Italy, of rich variation in language, custom, tradition, taste. But, above all, one would become aware of a continuum of old and new wherein a very ancient heritage permeates the fabric of the most audacious statement of the moment. The formal order and elegance of the Florentine Renaissance are still mirrored in the most contemporary art of the city, while the pagan legacy of Greece and the Roman Empire reverberates in the work of artists living in towns along the Adriatic coast, in southern Italy and in Rome. It is the identification with place, the view of history as a living entity, the respect for culture and craft, as well as a keen awareness of the international community of contemporary art by the Italian artists that lend their work an extraordinary diversity and dynamism.

While the legacy of the distant past enriches contemporary Italian art, it is by no means the only source of inspiration. Italians are fond of remarking to Americans, "our nation is younger than yours," to emphasize the importance and relevance of their recent history. Indeed, the history of early twentieth-century art, especially that of Metaphysical painting, and of more recent movements such as *Arte Povera* of the sixties, for the young Italians stands in a complex and often paradoxical relationship to the history of the remote past that has not become a mere document but is as real as the most recent event.

Crucial to an analysis of Italian art today is an understanding of the important but short-lived Metaphysical school, which flourished at the end of the second decade of the century. The Metaphysical painters, who can only very loosely be considered a school, include Giorgio de Chirico (still the best-known exemplar of the style outside of Italy), Carlo Carrà (who had been a leading Futurist), de Chirico's younger brother Alberto Savinio, Filippo de Pisis, Mario Sironi. These artists attempted to reform the classical vision of the Renaissance, especially in terms of perspective, the use of volumetric figures and objects and the depiction of a particular, finite world. Through irrational juxtapositions of these forms and distortions of space, they created a strange and disquieting atmosphere. By 1920 many of the painters associated with the *Scuola Metafisica* had reverted to a more traditional style inspired by classical Italian art.

Then, as now, as Carrà himself explained, the most avant-garde commitment on the part of Italians was tempered by a fascination for early Renaissance art, in particular for Giotto and Uccello. Allegorical, mythological and oriental subjects, themes of androgeny and hermaphroditism, and deliberate clumsiness in drawing, paint handling and in the representation of perspectival space became preoccupations of artists in the 1920s and 1930s; significantly, they are central concerns of many young contemporary Italian artists.

De Chirico, de Pisis, Carrà, Savinio, Osvaldo Licini, Ottone Rosai, Scipione (Gino Bonichi), Pio Semeghini, Italo Cremona, Fausto Pirandello and others, because they shared these preoccupations in the decades following World War I, may be seen as important forerunners of the recent group of Italian artists identified by the critic Achille Bonito Oliva as the trans-avantgarde. De Pisis and de Chirico can be singled out for other equally intriguing contributions to present-day Italian art. De Pisis is particularly fascinating in his use of self as the starting point of his art, for a flamboyance and theatricality that is mirrored in the Performance Art and some of the most compelling painting and sculpture of Italy in the 1960s and 1970s. De Chirico, on the other hand, fuses romanticism with a sense of the irrational and the fantastic and elevates commonplace objects and environments to a metaphorical realm to create a larger poetic reality. His romanticism is of late nineteenth-century origin; his dislocation of objects, abrupt changes in scale, the aura of enigma and the dream are influenced by northern artists such as Boecklin and Klinger and the writings of Nietzsche. These characteristics we have come to associate not only with *Pittura Metafisica* but with contemporary Italian art as well.

In contrast, the adherents of *Arte Povera*, the dominant movement of the 1960s, were, like their American counterparts, drawn to a reductive imagery, a minimal and conceptual framework, on the one hand, and to an art that was extremely physical in nature on the other. During the mid-1960s the Greek-born, Rome-based artist Jannis Kounellis presented a series of tableaux-vivants that incorporated live birds and animals, plants and human beings. These were comparable to the Happenings that occurred in New York during the 1960s, while an emphasis on modular form and on process and concept, rather than on end product, were common to both Italian and American art. Despite similarities, however, painting, sculpture and Performance Art differ significantly in this period. The recovery of myth, the symbolic meaning in performance and dance of fire and ritual, the organic harmony of art and of nature at its most elemental, the renewed preoccupation with alchemy are fundamental to even the sparest forms of expression in recent Italian art. These concerns, deep-rooted in the Italian heritage and imagination, are neither integral to our culture nor germane to our history and, thus, are not central to our art.

The return to expressionist imagistic painting in the late 1970s, in Italy as in the United States, was an inevitable reaction to the conceptual, reductive, largely non-imagistic art of the 1960s, just as Pop Art developed inevitably out of Abstract Expressionism. Just as Pop Art owes a debt to Abstract Expressionism, Italian expressionist imagist painting cannot be entirely separated from the movements that preceded it: many of these young Italian image-painters were themselves practitioners of a minimalist art during the 1970s. Furthermore, the Italians do not confine their admiration at any one time to any one kind of expression, but are inspired by artists as diverse as Duchamp and Beuys, Warhol and Gilbert and George, Rauschenberg and Johns, and the Rome-based Twombly, as well as the best American painting and sculpture of the 1950s and 1960s.

The seven artists in this exhibition—Sandro Chia, Enzo Cucchi, Nino Longobardi, Luigi Ontani, Vettor Pisani, Giuseppe Penone, Gilberto Zorio—are not meant to be seen as members of a single, identifiable movement or school but to express the ongoing vitality of Italian art today. Chia's uncommonly voracious appetite is stimulated by Cocteau, Malevich, Léger, Rosai, de Kooning, the art of Pompeii and the art of the streets. His is an art that celebrates the universe of the imagination and the drama of pure painting. Cucchi is more self-enclosed, drawing inspiration from a more concentrated vision, rooted in saints, medieval mysteries and strong, primitive color. Zorio and Penone, both based in Turin, share a common use of reductive forms and certain materials, such as terra-cotta. But Zorio's crystalline sculpture synthesizes the lean and the sensual, the rational and the alchemical, while Penone's work recalls Brancusi in its expression of the mystery of nature and a sense of its organic structure. Pisani and Ontani both evolve out of performance. Like de Pisis, Ontani travels through his artistic adventures in various disguises. He is like both St. Exupéry and his voyager, *le petit prince*. He re-creates the vision of a child, calling upon mythology, nursery rhymes or cartoon characters, endowing his work with the flavor of innocence tinged with eroticism, with humor and fantasy. On the other hand, Pisani, like de Chirico, is fascinated by northern artists such as Boecklin, Khnopff and Beuys. Duchamp is also a major source for his complex, hermetic and visually compelling art. Longobardi has integrated props such as tiger skins and chairs into otherwise spare canvases and has attached various painted objects to the encrusted surfaces of other paintings. More recently, a devastating earthquake in Naples has inspired a series of works depicting nature in chaos, populated by disquieting, spectral figures.

Thus, Chia, Cucchi, Longobardi, Pisani, Penone, Ontani and Zorio, uniquely different as artists, are nourished by the complex and various traditions that fuse in the crucible of their homeland and create new expressions that constitute aspects of Italian art today.

# Sandro Chia

Statement by the artist

*Nowadays there is said to be a new interest in painting. Therefore, painting faces the task of becoming even more interesting.*

*In order for such an attempt to succeed, it is necessary, above all, to recall the most interesting aspect of painting. This may sound pretentious in a time of so much analytical and sociological criticism in art. On the contrary, it is possible that dealing with such things has obscured the most interesting aspect of painting. Because what is the most interesting in painting is the chasm which divides painting from other things. Simultaneously, the chasm is the means by which painting relates to other things. Considering that the chasm (between painting and other things) is the most interesting aspect of painting means that between painting and other things there is no bridge but a jump. How ridiculous and damaging are those provisional bridges thrown up in order to facilitate commerce between painting and other things. The chasm which separates and joins painting and other things only becomes generative and rich in potential as it becomes more visible and insuperable: Masaccio, Piero della Francesca, Leonardo, Lotto, Raffaelo, Tiziano, El Greco, Caravaggio, Rembrandt, Turner, Cézanne, Monet, Renoir, Munch, Matisse, Mondrian, Malevich, Picasso, Carrà, de Chirico, de Kooning, Bacon Klein, Pollock, Beuys, Lichtenstein, Warhol, Twombly, Johns.*

Born in Florence, 1946
Accademia di Belle Arti, Florence, degree 1969
Travels throughout Europe and India, 1970
Settles in Rome, 1970
Establishes studio in New York, 1980
Lives and works in New York and Ronciglione

Sandro Chia's artistic vision is encyclopedic in scope. He draws unabashedly on diverse sources —cultural, historical and art historical—and assimilates them within the context of his personal experience to create an art of great originality and freshness. He states, "what I'm trying to put into my work is what I am. Culturally, anthropologically. . . . People say I'm in a European tradition, but I'm making graffiti from what I know. This tradition is something I ate with my food as a child, because I was born in a certain place."[1]

Chia's birthplace and home for twenty-four years was Florence, a city whose rich artistic traditions date back to the thirteenth century, when it was already a center for artists and artistic training. In Florence art is a part of life, integrated into everyday experience. This exposure was particularly important in Chia's development: he relates, for example, how as a youth he played soccer in Santo Spirito and afterwards went into the Church of Sta. Maria del Carmine to look at Masaccio's frescos. In 1970, curious about the world outside of Florence, Chia embarked on a year-long journey throughout Europe and India. Upon his return, he moved to the more metropolitan city of Rome, where he set up a studio. His first one-man show at Galleria La Salita in 1971 affirmed his origins in Conceptual Art, the dominant movement in Italy at the time. Entitled *L'ombra e il suo doppio* (*The Shadow and Its Double*), the exhibition presented an ensemble of objects (a plastic rose, a stuffed bird, a toy and two vials) positioned on the ground around a light source in the center of the room. The shadows of these objects, which constituted their "doubles," were projected onto four white panels hung on the walls. Although Chia's work changed radically over the course of the next ten years, the double image would recur throughout his oeuvre (for example, *Genoa*, 1981, cat. no. 4).

While Conceptualism and Minimalism expanded his perception, Chia felt constrained by their limitations in terms of solving painterly problems. As he gradually disengaged himself from the ordered strategies and impersonality of these modes, he moved toward an art based on intuition and synthesis, a more open painting that celebrates the physical properties of the medium with an explosive exuberance of color and brushwork. The drama of the surface quality of these canvases is enhanced by highly personal imagery rich in metaphor, fantasy, allegory, emotion and nostalgia. Perhaps paradoxically, though the canvases are extremely

extroverted, they are born of purely internal motives. The artist's presence is felt throughout: his inventiveness, instinct and imagination give new life to images with a past.

The notion of an art that has returned to its internal motives has been espoused by the critic Achille Bonito Oliva, who calls for the artist to take a "nomadic" position in order to roam freely through all the realms of art and the history of art: "Today, making art means having everything on the table in a revolving and synchronous simultanety which succeeds in blending inside the crucible of the work both private and mythic images, personal signs tied to the individual's story and public signs tied to culture and art history."[2] Though Chia eschews identification with movements or groups of artists, his work affirms this credo.

Chia engages in a pictorial discourse replete with wide-ranging cultural associations. In works such as *Heraclitus and His Other Half, Dionysus' Kitchen* and *To You Treacherous Wagon!* (cat. nos. 7, 5), where an orange donkey shatters the peacefulness of a rural setting by kicking his carriage, which is emblazoned with a large white cross, he appropriates subjects from the realm of religion, philosophy and mythology as well as Mediterranean folktales and everyday life. By incorporating several disparate references into a single painting, Chia reinvents historical themes and invests them with new and timely meaning. Though his sources seem obvious for the most part, in dislocating them from their contexts, he transcends their original meaning. Chia's simultaneous veneration and denial of his sources and his sardonic wit give the work its vitality: his paintings are at once ingratiating and disobedient, angelic and impolite.

In removing his subjects from their accustomed contexts, Chia does not engage in the transformations typical of Surrealism, a movement he disavows for its intellectual approach, its literalism and its lack of painterliness. He is, rather, much closer in spirit to the Italian Metaphysical painters, de Chirico and Carrà. Both the Metaphysical painters and the Surrealists juxtaposed unrelated, commonplace objects in often bizarre environments so that these objects took on new characters as magical and autonomous entities, reflecting the inner world of the artist's imagination. Surrealism emphasized the fantastic, the accidental and irrational and, drawing on Freudian precepts and dream symbolism, depicted the world of the subconscious as a new reality, a "super reality." The Metaphysical painters, who preceded the Surrealists, originally focused upon the magical effects of strange juxtapositions; however, they later were committed, above all, to a return to Italian tradition and craftsmanship, and sought to restore to prominence the values of Italian Quattrocento and Cinquecento painting. Drawn to the classicism and purity, the architectonic structure and perspectival innovations, the dramatic chiaroscuro of these paintings, in particular they admired Piero, Masaccio and Giotto.

An understanding of the Metaphysical painters' identification with Italian history and their love of commonplace objects is fundamental to an understanding of Chia's work. Both Carrà and de Chirico wrote about the importance of the commonplace in art: Carrà wrote in 1919 in *Pittura Metafisica* "It is the ordinary things that reveal the simplicity which points to a higher and more hidden state of being and which is the very secret splendor of art." In his Metaphysical landscapes de Chirico depicted a silent, motionless dream-world with deep perspectives and strong shadows, no-man's lands in which man-made objects shed their accustomed identities for often indecipherable new ones. Chia especially admires de Chirico and is inspired by the aura of mystery in his work, noting that for de Chirico there is mystery in a still life, in simple things. And like de Chirico, Chia imbues the most commonplace situations and the most ordinary of objects with great mystery. Chia's is not an ambiguity that invites us to search for solutions, but a deliberately created ambiguity that elevates his subject matter to the level of metaphor.

Chia's specifically art-historical quotations operate on stylistic as well as thematic levels. He ingeniously combines both the formal and iconographic inventions of older Italian traditions (especially the early Renaissance, Mannerist and Baroque pe-

riods) and of nineteenth- and early twentieth-century movements (Post-Impressionism and expressionist modes including Fauvism, Futurism and Primitivism). Though in mood Chia's work is most akin to Metaphysical painting, stylistically it has more in common with expressionism, in particular in its repudiation of finish and refinement. Indeed, Chia embraces many techniques and effects typical of expressionism, such as deliberate crudity of drawing and paint handling, surfaces made palpable and activated by audacious scribblings of thick paint. He reinforces the discordant textures he achieves with brilliant, often strident colors that sharply intrude upon an otherwise somber palette. Recently Chia has begun to use oil sticks; these allow him greater freedom to execute very direct coloristic drawing, which invests his work with tremendous energy.

From these highly energized fields the figure emerges. The figure is always engaged in activity, generally the simplest of rituals, and serves as a barometer of the painting's evolution for Chia. He says, "I know a painting is finished when the figure is all grown up." In the more recent painting, sculptural modeling recalls Matisse: the figure takes shape as three-dimensional form through the use of line and color. Curves define volume and flatness simultaneously, and establish an independent pattern of linear rhythms across the surface of the canvas. The human form is the central image for Chia as for Matisse, the thread that runs throughout all their work. However, the emotional range of Chia's figures, and hence canvases, extends from playfulness and joy to tragedy and despair. Thus the complexity of Chia's vision is at odds with the clear, harmonious and ultimately hedonistic world depicted by Matisse.

One of the artists Chia most admires for his fusion of formal concerns and poetic content is Chagall. Chagall's deliberate contrasts of earth tones and brilliant primaries, the calculated clumsiness of his drawing, the figures' defiance of gravity parallel Chia's own solutions. And Chagall, like Chia, subordinates all individual details to the total experience of the work of art. Moreover, the ethereal nature of his floating figures creates a metaphysical energy which Chia believes should be at the heart of painting. As Chia stated in a recent interview, "Now a painting is not just an object. It has an aura again. There is a light around the work. . . . It is the same feeling, I think, that Renaissance people got from painting. It is a miracle, in a way. . . . Painting is made with heavy . . . dirty things. But they become light. They become metaphysical in the minds of people looking at them."[3] The concept of the aura of the painting is central for Chia. He believes that paintings should not convey a message, but an atmosphere. The spectator is captured in the intense field of the individual work or group of works and partakes of this aura.

Malevich is another master of the early twentieth century with whom Chia shares a spiritual kinship. In his pictures of peasants, which preceded his Suprematist works, Malevich painted the most ordinary of subjects—peasants laboring at mundane activities such as washing, gardening and cutting wood. The bucolic primitivism of Malevich's scenes, the brilliant spectral colors and tubular volumes, the clumsy, oversize figures which dominate their surroundings find counterparts in Chia's own canvases. Malevich transcended the earthbound realm of these works only in his later, abstract Suprematist paintings; Chia, on the other hand, explores the metaphysical implications of ordinary existence in his depictions of commonplace life. In his Suprematist paintings Malevich used floating or ascending shapes to convey the idea of the expansion of man's psychic life beyond the world of earthly things. Chia, too, interprets the theme of floating to reinforce metaphysical content but, as previously stated, more literally, in the guise of floating human figures.

Chia is attuned not only to European painting of the early years of this century, but also to artistic developments that took place in the United States in the fifties and sixties. The presence of Twombly in Rome since the late fifties was an important catalyst for Italian artists of Chia's generation. Twombly's ability to work within the framework of Conceptualism and Minimalism while maintaining a painterliness by means of his crosshatching, scratchy and scribbled brushstrokes is reflected in

Chia's own painting. Pop artists also attract Chia, especially Warhol for his high-key, day-glo color, which, although unrealistic, was successfully integrated into naturalistic imagery, and for the ironic power of his banal subject matter. Moreover, Lichtenstein provides precedents for Chia's own use of commonplace subject matter and his learned quotations from art history—quotations which remain identifiable yet are interpreted through his own sensibility. Lichtenstein's ability to transcend commonplace subject matter while preserving the essence of its original nature as well as his practice of drawing upon a broad range of art history finds parallels in Chia's own art. While the Pop artists approached the history of art as a series of movements to be treated sequentially, Chia, on the other hand, uses his painting as a crucible in which past art and personal vision meet and fuse in continuous and free interplay without reference to chronological distinctions.

Chia ultimately achieves an extraordinary synthesis of disparate material and thereby creates works which are at once richly eclectic and uniquely personal. He has produced a prolific body of work resonant with a poetry and spirit that transcends the tangible. Yet, in the viewing experience, the phenomenal qualities of his paintings are inescapable.

## Footnotes
See individual artist's bibliographies for complete references.
1. Ratcliff, *Interview*, 1981, p. 85
2. Bonito Oliva, *The Italian Trans-avantgarde*, 1980, p. 18
3. Ratcliff, *Interview*, p. 85

## Selected Group Exhibitions
Museum of the Philadelphia Civic Center, *Italy Two: Art Around '70*, November–December 1973. Catalogue with texts by Alberto Boatto, Furio Colombo and Filiberto Menna

Musée d'Art Moderne de la Ville de Paris, *10ème Biennale de Paris: Manifestation internationale des jeunes artistes*, September 1977

Galleria Sperone, Rome, *Sandro Chia / Giulio Paolini / Salvo*, 1977

Galerie Paul Maenz, Cologne, *Arte Cifra*, June–July 1979. Catalogue with texts by Germano Celant and W. Max Faust

Stuttgart, *Europa 79*, October 1979

Castello Colonna, Genazzano, *Le Stanze*, November 1979. Catalogue with text by Achille Bonito Oliva

Palazzo di Città, Acireale, *Opere fatte ad arte*, November 1979. Catalogue with text by Achille Bonito Oliva

Emilio Mazzoli, Modena, *Tre o quattro artisti secchi*, 1979

Bonner Kunstverein, Bonn, *Die enthauptete Hand—100 Zeichnungen aus Italien*, January 1980. Traveled to Städtische Galerie, Wolfsburg; Groninger Museum, Groningen, The Netherlands. Catalogue with texts by Achille Bonito Oliva, W. Max Faust and Margarethe Jochimsen

Francesco Masnata, Genoa, *Sandro Chia, Francesco Clemente, Enzo Cucchi, Nicola De Maria, Mimmo Paladino*, March 1980

Galleria Sperone, Turin, *Chia, Cucchi, Merz, Calzolari*, March 1980

Kunstverein, Mannheim, *Egonavigatio*, March 1980. Catalogue with texts by Jean-Christophe Ammann, Achille Bonito Oliva, Germano Celant, W. Max Faust and Margarethe Jochimsen

Kunsthalle Basel, *Sandro Chia, Francesco Clemente, Enzo Cucchi, Nicola De Maria, Luigi Ontani, Mimmo Paladino, Ernesto Tatafiore*, May–June 1980. Traveled to Museum Folkwang, Essen; Stedelijk Museum, Amsterdam. General catalogue with texts by Jean-Christophe Ammann, Achille Bonito Oliva and Germano Celant; supplementary catalogue on Chia with text and drawings by the artist

Venice, *La Biennale di Venezia: Aperto '80, mostra internazionale di giovani artisti*, June 1980. Catalogue with texts by Achille Bonito Oliva and Harald Szeemann

Galerie Rudolf Zwirner, Cologne, *Neuerwerbungen*, October 1980

Sperone Westwater Fischer, New York, *Sandro Chia, Francesco Clemente, Enzo Cucchi*, October 1980

Musée d'Art et d'Industrie, Saint-Etienne, *Après le classicisme*, November 1980. Catalogue with texts by Jacques Beauffet, Anne Dary-Bossut and O. Semin

Palazzo di Città, Acireale, *Genius Loci*, November–December 1980. Catalogue with text by Achille Bonito Oliva

Daniel Templon, Paris, *Chia, Clemente, Cucchi, De Maria, Paladino*, December 1980–January 1981

Loggetta Lombardesca, Ravenna, *Italiana: nuova immagine*, 1980

The Museum of Modern Art, New York, *Recent Acquisitions: Drawings*, March–June 1981

Museen der Stadt, Cologne, *Westkunst-Heute*, May–August 1981. Catalogue with text by Kasper Koenig

Anthony d'Offay, London, *New Work*, July–August 1981

The Royal Academy, London, *A New Spirit in Painting*, August 1981. Catalogue with texts by Christos Joachimides, Norman Rosenthal and Nicholas Serota

Sperone Westwater Fischer, New York, *Sandro Chia, Francesco Clemente, Enzo Cucchi, Carlo Mariani, Malcolm Morley, David Salle, Julian Schnabel* (drawings), September 1981

Bernard Jacobson Ltd., Los Angeles, *New Work by Chia, Cucchi, Disler, Penck* (prints), October–November 1981

Albright-Knox Art Gallery, CEPA Gallery and HALL-WALLS, Buffalo, New York, *Figures: Forms and Expressions*, November 1981. Catalogue with texts by Robert Collignon, William Currie, Roger Denson, Biff Henrich, Charlotta Kotik and Susan Krane

Galleria Sperone, Turin, 1981

**Selected One-Man Exhibitions**

Galleria La Salita, Rome, *L'ombra e il suo doppio*, May 1971; 1972; February 1973; June 1974; 1975; June 1976

Galleria Diagramma, Milan, 1972

Galleria De Domizio, Pescara, *Graziosa girevole*, May 1975

Galleria L'Attico, Rome, 1975

Galleria Tucci Russo, Turin, March 1976; 1978

Emilio Mazzoli, Modena, February 1977

Galleriaforma, Genoa, 1977

Galleria Sperone, Rome, 1977; December 1979

Galleria De Crescenzo, Rome, March 1978

Galerie Paul Maenz, Cologne, November 1978; 1980

Framart Studio, Naples, 1978

Galleria dell'Oca, Rome, 1978

Galleria Mario Diacono, Bologna, January 1979. Catalogue with text by Mario Diacono

Sperone Westwater Fischer, New York, January 1980; April 1981

Art and Project, Amsterdam, March 1980

Anthony d'Offay, London, December 1981–January 1982

**Selected Bibliography**

BY THE ARTIST

*Bibliographie*, Rome, 1972

*Intorno a se*, Rome, 1978. Published on occasion of one-man exhibition, Galleria De Crescenzo, March 1978

*Mattinata all'opera*, Modena, 1979

With Achille Bonito Oliva and Enzo Cucchi, *Tre o quattro artisti secchi*, Modena, 1979

*Carta d'Olanda*, Amsterdam, 1980

*Manuale d'aprile—April Manual*, New York, 1981

*Illustrated by the artist*

Roberto Triana Arenas, *Bestiario*, Rome, 1980

ON THE ARTIST

*Newspapers and Periodicals*

Luciana Rogozinski, "Sandro Chia: Mario Diacono/Bologna," *Flash Art*, no. 88-89, March–April 1979, p. 54

Marlis Grüterich, "Galerie Paul Maenz, Cologne," *Pantheon*, October 1979, p. 308

Achille Bonito Oliva, "La trans-avanguardia italiana," *Flash Art*, no. 92-93, October–November 1979, pp. 17-20

Francesco Vincitorio, "Dice Sandro Chia," *L'Espresso*, no. 5, February 3, 1980, p. 91

Corinna Ferrari, "Stanze del Castello," *Domus*, no. 604, March 1980, p. 55

"Italienische Kunst Heute," *Kunstforum*, vol. 39, March 1980. Special issue

Thomas Lawson, "Sandro Chia at Sperone Westwater Fischer," *Art in America*, vol. 68, March 1980, p. 122

Achille Bonito Oliva, "The Bewildered Image," *Flash Art*, no. 96-97, March–April 1980, pp. 32-35, 38-39, 41

Laura Cherubini, "The Rooms: Castello Colonna/Genazzano," *Flash Art*, no. 96-97, March–April 1980, pp. 42-43

Kay Larson, "Bad Boys at Large! The Three Cs Take On New York," *The Village Voice*, vol. 25, September 17-23, 1980, pp. 35, 37

William Zimmer, "Italians Iced," *The SoHo Weekly News*, vol. 8, October 8-14, 1980, p. 45

Ginestra Calzolari, "Sandro Chia," *Acrobat Mime Parfait*, October 1980, pp. 24-27

R. G. Lambarelli, "Sandro Chia, del paradosso o della parodia," *Acrobat Mime Parfait*, October 1980, pp. 16-23

Thomas Lawson, "Chia, Clemente and Cucchi," *Flash Art*, no. 100, November 1980, p. 43

Jean-Christophe Ammann, Paul Groot, Pieter Heynen and Jan Zumbrink, "Un altre arte?," *Museumjournaal*, serie 25, December 1980, pp. 290-291

Cynthia Nadelman, "Sandro Chia, Francesco Clemente, Enzo Cucchi," *Art News*, vol. 19, December 1980, p. 193

Carrie Rickey, "New York: Sandro Chia, Enzo Cucchi, and Francesco Clemente: Sperone Westwater Fischer," *Artforum*, vol. 19, December 1980, pp. 70-72

Jean-Christophe Ammann, *Annuario Skira*, Geneva, 1980, passim

Henry Martin, "The Italian Scene, Dynamic and Highly Charged," *Art News*, vol. 80, March 1981, pp. 70-77

Achille Bonito Oliva, "Sandro Chia," *Domus*, no. 618, June 1981, p. 55

Thomas Lawson, "Sandro Chia: Sperone Westwater Fischer," *Artforum*, vol. 19, June 1981, p. 91

René Ricard, "Not About Julian Schnabel," *Artforum*, vol. 19, June 1981, pp. 74-80

Carter Ratcliff, "a new wave from Italy: Sandro Chia," *Interview*, vol. 11, June–July 1981, pp. 83-85

Hilton Kramer, "Expressionism Returns to Painting," *The New York Times*, July 12, 1981, Section 2, pp. D1, D23

Nigel Gosling, "Looking at the Eighties," *The Observer*, August 16, 1981, p. 24

René Payant, "From Landuage to Landuage," *Parachute*, Summer 1981, pp. 27-33

Roberta Smith, "Fresh Paint," *Art in America*, vol. 69, Summer 1981, pp. 70-79

Richard Armstrong, "Cologne: 'Heute,' Westkunst," *Artforum*, vol. 20, September 1981, pp. 83-86

Jeff Perrone, "Boy Do I Love Art or What," *Arts Magazine*, vol. 56, September 1981, pp. 72-78

Carter Ratcliff, "The End of the American Era," *Saturday Review*, September 1981, pp. 42-43

Jean Rouzaud and Emile Laugier, "Vive la peinture-peinture!" *Actuel*, no. 23, September 1981, pp. 80-81

"Die Neue Malwut," *Stern*, Hamburg, no. 41, October 1, 1981, pp. 40-60

Michael Krugman, "Sandro Chia," *Art in America*, October 1981, pp. 144-145

"Malerei '81: Triumph der Wilden," *Art Das Kunstmagazin*, no. 10, October 1981, pp. 32-43

Pari Stave, "Sandro Chia," *Art News*, vol. 80, October 1981, pp. 224-225

Danny Berger, "Sandro Chia in His Studio: An Interview," *The Print Collector's Newsletter*, vol. XII, January–February 1982, pp. 168-169

*Books*

Achille Bonito Oliva, *Europa-America*, Milan, 1976

Achille Bonito Oliva, *The Italian Trans-avantgarde*, Milan, 1980

Anne Seymour, *The Draught of Dr. Jekyll: An Essay on the Work of Sandro Chia*, London, 1981

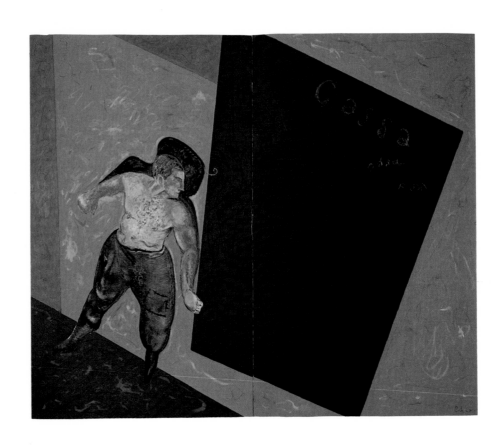

**1**
*Bones, Coffin, Ditch (Ossa, cassa, fossa).* 1978
Oil on canvas, 69 x 82½ ʺ (175 x 210 cm.)
Private Collection, Turin; Courtesy Sperone
Westwater Fischer, New York

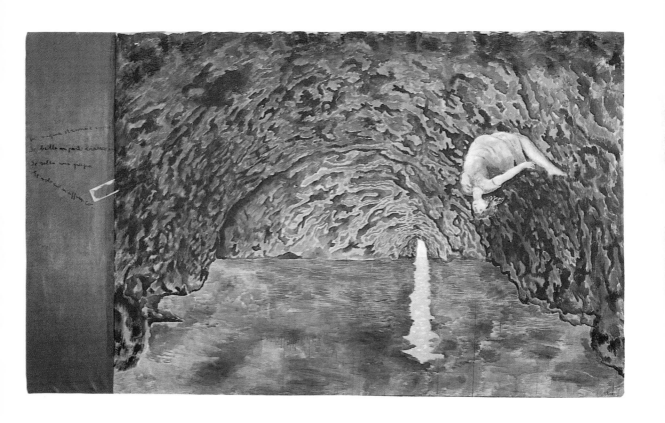

**2**
*In Strange and Gloomy Waters If a White Dot Shines
If a Child Jumps I Will Approach Her Flight (In acqua
strana e cupa se brilla un punto bianco se salta una
pupa al volo suo m'affianco).* 1979
Oil on canvas, 78¾ x 140″ (200 x 355.5 cm.)
Collection Stedelijk Museum, Amsterdam

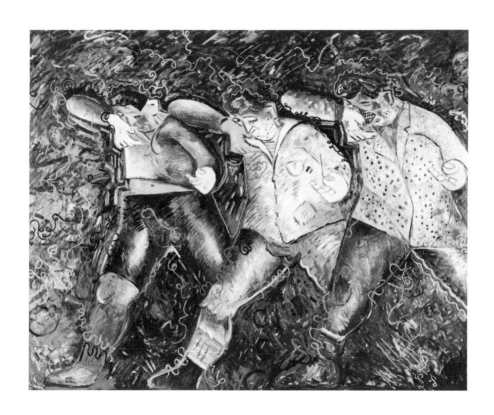

**3**

*Brutes as Protagonists of a Monkey's Erotic Fantasy
(Energumeni come protagonisti della fantasia
erotica di una scimmia).* 1979-80

Oil on canvas, 67⅝ x 84″ (172 x 213 cm.)

Private Collection

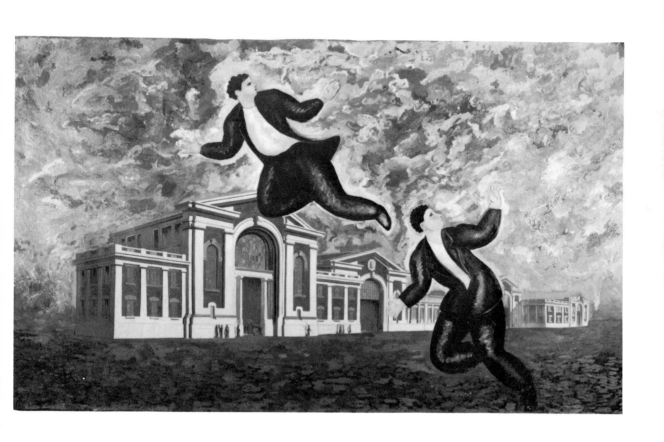

**4**
*Genoa (Genova).* 1980
Oil on canvas, 89 x 156″ (226 x 396 cm.)
Collection Heiner Bastian, Berlin

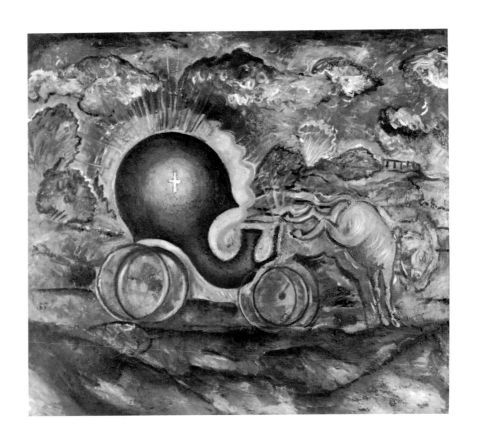

**5**
*To You Treacherous Wagon! (A te perfido carro!).*
1980
Oil on canvas, 51 x 59″ (130 x 150 cm.)
Private Collection; Courtesy Sperone Westwater
Fischer, New York

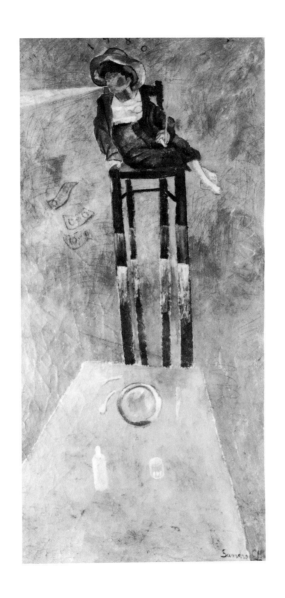

**6**
*Happy New Year.* 1980
Oil on canvas, 70¾ x 39¼ ″ (180 x 100 cm.)
Collection Céline Bastian, Berlin

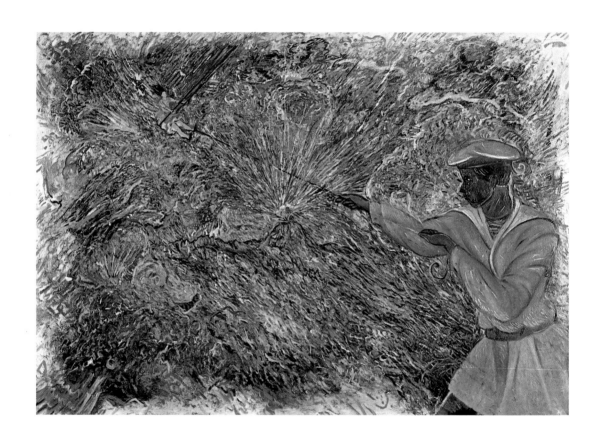

**7**
*Dionysus' Kitchen.* 1980
Oil on canvas, 77 x 110″ (196 x 280 cm.)
Collection Erich Marx, Berlin

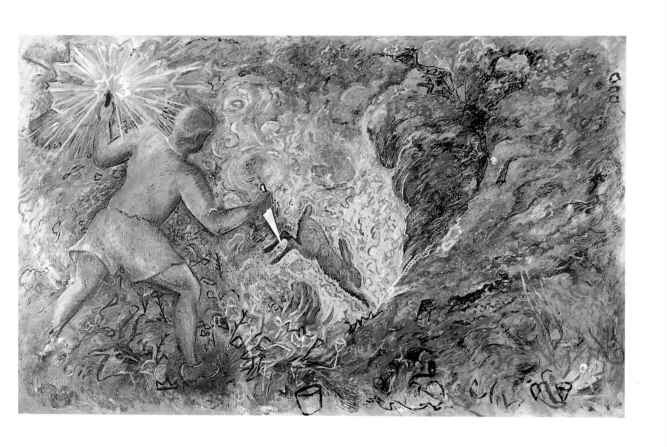

**8**
*Rabbit for Dinner.* 1981
Oil on canvas, 81 x 133½ ″ (205.5 x 339 cm.)
Collection Stedelijk Museum, Amsterdam

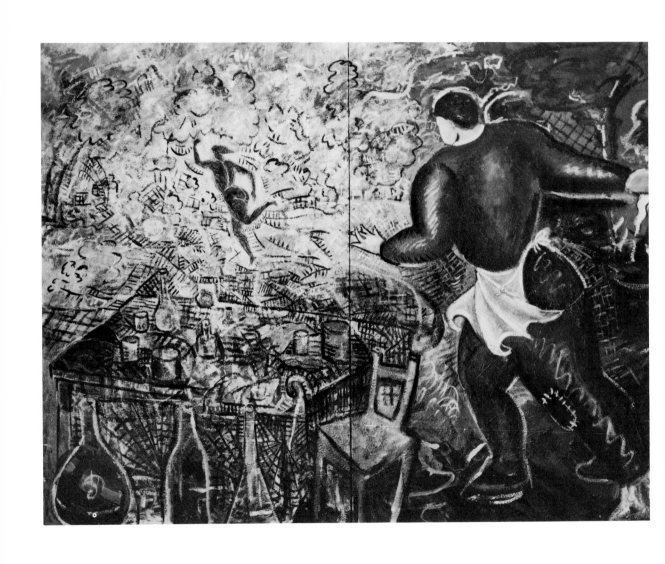

**9**
*The Pharmacist's Son (Il figlio del farmacista).* 1981
Oil on canvas, 76¾ x 102¼" (195 x 260 cm.)
Courtesy Gian Enzo Sperone, Rome

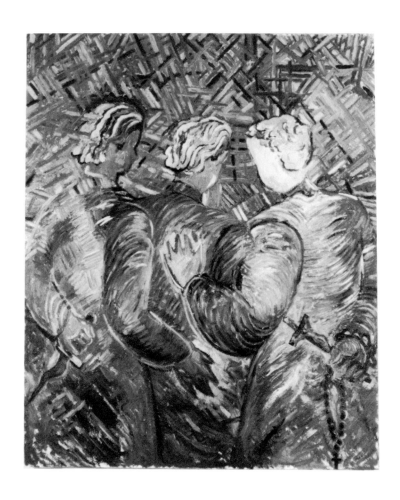

**10**

*Neophyte.* 1981

Oil on canvas, 47 x 39¼ " (119 x 100 cm.)

Private Collection; Courtesy Sperone Westwater
Fischer, New York

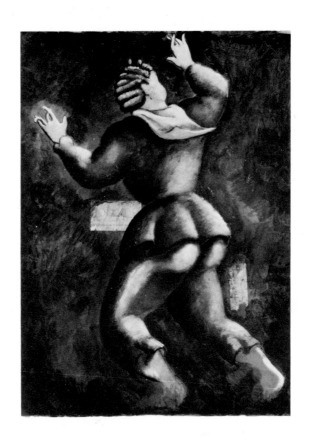

**11**
*Fingers Crossed (Dita intrecciate).* 1981
Tempera on paper, 36½ x 27″ (93 x 69 cm.)
Private Collection, Washington, D.C.

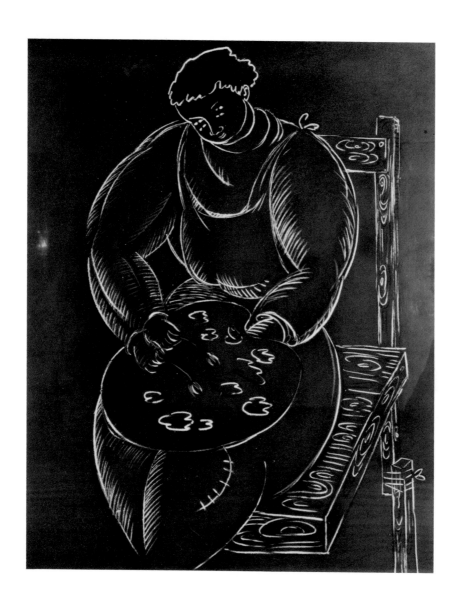

**12**

*Four Eyes, Three Hands.* 1981
Charcoal and pastel on gouache-painted paper,
73¾ x 59⅝″ (187.4 x 151.3 cm.)
Collection Barbara and Donald Jonas

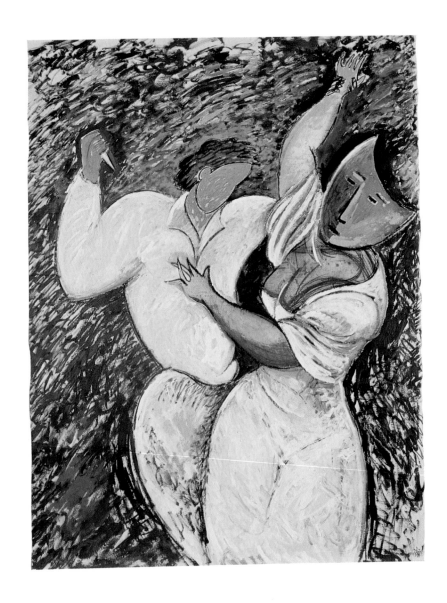

**13**
*Hand Game.* 1981
Pencil, charcoal and oil on paper, 77 x 59¼ ″
(195.5 x 150 cm.)
Collection Barbara and Donald Jonas

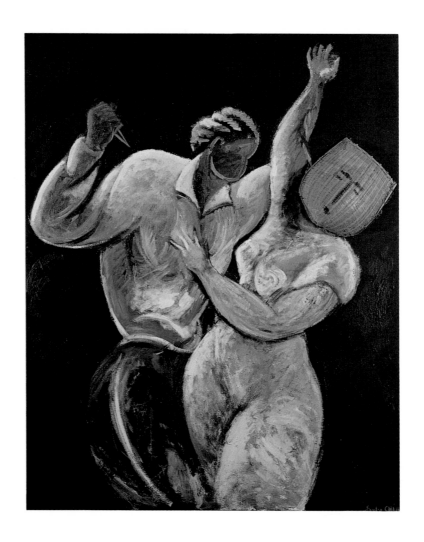

**14**
*The Scandalous Face (Il volto scandaloso).* 1981
Oil on canvas, 63 x 51″ (160 x 130 cm.)
Courtesy Gian Enzo Sperone, Rome

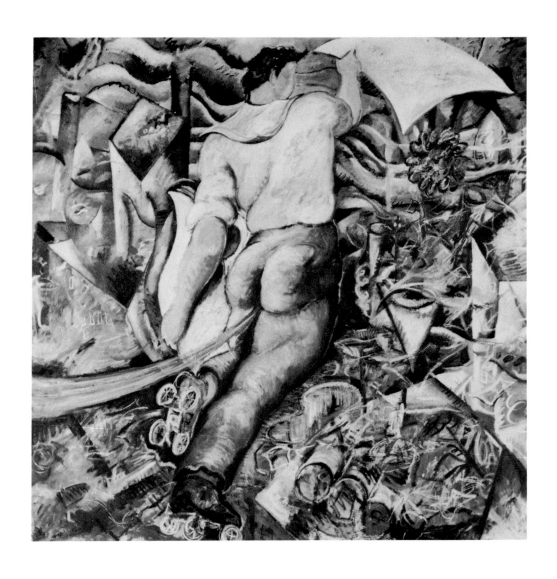

**15**
*Speed Boy.* 1981
Oil on canvas, 80¼ x 81⅛ ″ (204 x 206 cm.)
Collection Janet and Michael Green, London

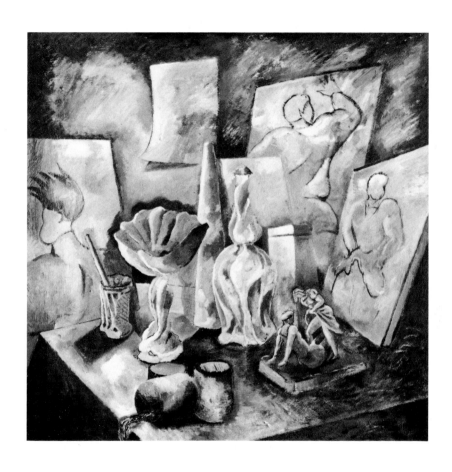

**16**
*Painting, Sculpture and Dust.* 1981
Oil on canvas, 61 x 61″ (155 x 155 cm.)
Private Collection, New York

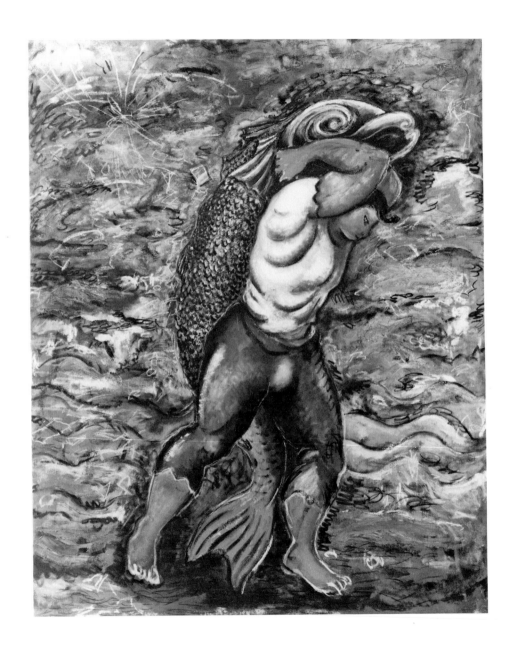

**17**
*Water Bearer.* 1981
Oil and oil pastel on canvas, 81¼ x 67″ (206 x
170 cm.)
Courtesy Anthony d'Offay Gallery, London

# Enzo Cucchi

Statement by the artist
***Art loves the world***

Born in Morro d'Alba, Marches, 1950
Lives and works in Ancona

Enzo Cucchi's dynamic and monumental canvases are characterized by an instinctive, painterly directness. Their forcefulness of expression depends upon both the visionary poetics of Cucchi's narratives of confrontation and survival, and the visceral quality of his vigorously handled paint, color and drawing. The combination of the poetic with the extremely physical results in paintings that are tough and provocative, spirited and robust.

Cucchi's art is intimately connected to the surroundings amid which he grew up. For the past seven years, he has lived and worked in the port city of Ancona, on the Adriatic Sea. Life in Ancona revolves primarily around the harbor; industry is closely bound to the marine world. It is, therefore, not surprising that the sea figures strongly in Cucchi's work. Moreover, the variations in terrain of this area, which is known as the Marches—the beautiful shoreline, steep ravines and dramatic rock formations—that distinguish the area find their counterparts in the undulating hills and sharp perspectival and scale changes in Cucchi's paintings. Ancona is a city of Greek origin and many monuments remain intact from the periods of Doric Greek and Roman colonization. Although this history has bestowed upon Cucchi a sense of artistic tradition, his imagery depends first and foremost on his personal past. He states, "You discover images just once in your lifetime . . . among faded, lifeless and untamed forms. . . . A painter goes on being a painter for the idea of things, of mountains, of women. Men are painters, cyclists, mountaineers, woodsmen, sailors, hunters, warriors."[1]

As Cucchi sees himself as part of his surroundings, so he depicts man and his environment as inextricably intertwined. His narrative style speaks to the themes of man's destiny and the difficulty of survival in an often violent world. His landscapes are inhabited by strange, primordial figures, shown nude and rendered schematically, that appear to play the roles of victor or victim, hunter or hunted. Ultimately, however, the meanings of these dramas are unclear, the iconography is impenetrable and open to many interpretations. The deliberate ambiguity of meaning is in dramatic contrast, however, to the clarity, simplicity and force of the formal vehicles used to convey that meaning: scale, color and paint surface are exploited to their fullest potential to heighten the urgency and impact of expression in these canvases.

Cucchi's surfaces seem to exhale brilliant, vivid color. He concentrates on primary and secondary colors, using them in their purest, harshest and most highly saturated form; subtle mixtures and pastels have no place in his palette. Frequently he abuts areas of color with their complimentaries, so that the intensity of each color is amplified by the other. Cucchi is also adept at using black, either in combination with primary colors or alone in the stark charcoal drawings or in the very large-scale paintings comprised of white drawing on black grounds, such as *Saint's Foot*, 1981. Cucchi executes all the colors in a single painting in the same value, so that every area of the canvas pulsates with equivalent intensity. Sometimes he lays on color with broad sweeps of the brush; sometimes he renders mountains or seas as single blocks of strident, undiluted color—here, the skin may occasionally open up to reveal gashes of equally strong color underneath. Always the sense of overpowering color is enhanced by the heroic scale of the canvas.

The materiality of paint is crucial in Cucchi's work—each mark on the canvas is significant in itself, as an individual piece of matter and also as part of the expressive whole. The artist is concerned with the density of each hue, the particular physical characteristics of each area of pigment. Free and open paint handling and forceful brushstrokes contribute a sense of brutality which reinforces the emphatic physical presence of surfaces.

Cucchi renders figures simply and economically with bold, summarizing contour lines. Dense color

and heavy impasto give these figures their corporeality. This weight Cucchi underscores by conveying a sense of the ever-present and powerful pull of gravity—figures plunge to earth from the sky (A *Fish on the Back of the Adriatic Sea* or *Ferocious Tongues* [cat. nos. 20, 22]) or menacingly stomp the earth with their exaggeratedly large feet (*Battle of the Regions* [cat. no. 27]). These figures—at first depicted as tiny, dwarfed by their surroundings—are oversized in relation to the landscapes upon which they are imposed with minimal, if any, perspectival or proportional integration. Dramatic foreshortenings pull the viewer into the space of the compositions. Shifts of scale are abrupt and arbitrary and create an environment that corresponds to the world of the artist's imagination, not the real world. Schematic presentation of figures, clumsy drawing, awkward proportions, simplified compositional structure and straightforward color combine to produce a naive, even primitive effect.

In both its reference to primordial nature and the physicality of its surfaces, Cucchi's painting is reminiscent of the work of Clyfford Still. Although it is unlikely that Cucchi, who has remained for the most part in the province of his birth, has seen Still's work firsthand, an exceptional similarity of feeling and purpose unite the two painters. Still deliberately isolated himself from the center and pressures of the art world, freeing himself to execute works that were majestic in scale, spirit and emotional range. Cucchi, too, has detached himself from the artistic mainstream, drawing inspiration from his immediate surroundings. Cucchi's raw, almost savage paint and color application recalls Still's own technique; his high-key colors, particularly the use of red, yellow, brown and white, find counterparts in Still's palette. In both the American's and the Italian's canvases, these colors suggest the primary elements. Still often cuts into the surface of his dense opaque color to open up chasms; Cucchi, as well, slashes the skin of his heavy paint. The intensity of Still's blacks, his affirmative brushstrokes, his troweled paint create a physicality seen also in the best of Cucchi's work. And, finally, the jagged configurations of Still's forms find contemporary parallels in Cucchi's angular landscapes and the nervous, irregular silhouettes of his bestial and human figures.

The artist has said that the only paintings he saw as a child were of saints in churches. These saints were Cucchi's earliest heroes, and his continuing fascination with them is revealed in numerous references to martyrdom (hands and feet with stigmata) and frequent use of crosses and halos (crowning both animate beings and inanimate objects). Most of the monuments surrounding Cucchi in Ancona evolved and were rebuilt over the centuries from Roman antiquity through medieval times; some date as late as the eighteenth century. Their proportions are eccentric, their volumes heavy, without the classic refinement and grace of Renaissance style. The primitivism of these massive buildings and the bas-reliefs and paintings that adorn them is reflected in the deliberate crudity and clumsiness of Cucchi's figures and landscapes. In a recent series called ferocious paintings (cat. nos. 22, 24), Cucchi depicts scenes with an obsessively repetitive palette of red, yellow, white and black in which images of severed heads, skulls, predatory beasts and ominous foliage with sawtooth edges frenziedly crisscross the canvas.

Although he is inspired by a wealth of external material—the landscapes and seascapes of Ancona, naive and expressionist painting, the holy images of past art—Cucchi's artistic decisions are based on intuition. Drawing upon his internal resources, he has achieved a dynamic balance between form and content and has cultivated as well an authentic feeling for paint and color. The mysterious imagery and brutal forms, the uningratiating color of Cucchi's paintings are fed by primeval sources of inspiration to constitute an art of harsh and primitive power.

**Footnote**

1. Cucchi, *Diciannove disegni*, 1980

**Selected Group Exhibitions**

Galleria Municipale, Modena, *Associazione, dissociazione, dissenzione dell'arte: l'estetico e il selvaggio*, May 1979

Palazzo delle Esposizioni, Rome, *Le alternative del nuovo,* June 1979

Stuttgart, *Europa 79,* October 1979

Castello Colonna, Genazzano, *Le Stanze,* November 1979. Catalogue with text by Achille Bonito Oliva

Palazzo di Città, Acireale, *Opere fatte ad arte,* November 1979. Catalogue with text by Achille Bonito Oliva

Emilio Mazzoli, Modena, *Tre o quattro artisti secchi,* 1979

Galerie Yvon Lambert, Paris, *Parigi: o cara,* 1979

Galleria Artra, Milan, *Labirinto,* 1979

Bonner Kunstverein, Bonn, *Die enthauptete Hand— 100 Zeichnungen aus Italien,* January 1980. Traveled to Städtische Galerie, Wolfsburg; Groninger Museum, Groningen, The Netherlands. Catalogue with texts by Achille Bonito Oliva, W. Max Faust and Margarethe Jochimsen

Francesco Masnata, Genoa, *Sandro Chia, Francesco Clemente, Enzo Cucchi, Nicola De Maria, Mimmo Paladino,* March 1980

Galleria Sperone, Turin, *Chia, Cucchi, Merz, Calzolari,* March 1980

Kunsthalle Basel, *Sandro Chia, Francesco Clemente, Enzo Cucchi, Nicola De Maria, Luigi Ontani, Mimmo Paladino, Ernesto Tatafiore,* May–June 1980. Traveled to Museum Folkwang, Essen; Stedelijk Museum, Amsterdam. General catalogue with texts by Jean-Christophe Ammann, Achille Bonito Oliva and Germano Celant; supplementary catalogue on Cucchi with text and drawings by the artist

Venice, *La Biennale di Venezia: Aperto '80, mostra internazionale di giovani artisti,* June 1980. Catalogue with texts by Achille Bonito Oliva and Harald Szeemann

Musée Nationale d'Art Moderne, Centre d'Art et de Culture Georges Pompidou, Paris, *XI Biennale de Paris,* September 1980

Sperone Westwater Fischer, New York, *Sandro Chia, Francesco Clemente, Enzo Cucchi,* October 1980

Palazzo di Città, Acireale, *Genius Loci,* November– December 1980. Catalogue with text by Achille Bonito Oliva

Daniel Templon, Paris, *Chia, Clemente, Cucchi, De Maria, Paladino,* December 1980–January 1981

Loggetta Lombardesca, Ravenna, *Italiana: nuova immagine,* 1980

The Museum of Modern Art, New York, *Recent Acquisitions: Drawings,* March–June 1981

Museen der Stadt, Cologne, *Westkunst—Heute,* May–August 1981. Catalogue with text by Kasper Koenig

Sperone Westwater Fischer, New York, *Sandro Chia, Francesco Clemente, Enzo Cucchi, Carlo Mariani, Malcolm Morley, David Salle, Julian Schnabel* (drawings), September 1981

Bernard Jacobson Ltd., Los Angeles, *New Work by Chia, Cucchi, Disler, Penck* (prints), October– November 1981

Galleria Sperone, Turin, 1981

### Selected One-Man Exhibitions

Galleria Luigi De Ambrogi, Milan, *Montesicuro, Cucchi Enzo giù,* 1977

Incontri Internazionali d'Arte, Palazzo Taverna, Rome, *Ritratto di casa,* 1977

Galleria De Crescenzo, Rome, *Mare Mediterraneo,* 1978; *Alla lontana, alla francese,* January 1979

Galleria Mario Diacono, Bologna, *La cavalla azzurra,* February 1979. Catalogue with text by Mario Diacono

Emilio Mazzoli, Modena, *La pianura bussa,* 1979; 1981

Galleria Tucci Russo, Turin, *Sul marciapiede, durante la festa dei cani,* 1979

Galleria dell'Oca, Rome, *Uomini con una donna al tavolo,* April 1980

Galerie Paul Maenz, Cologne, *5 morti sono santi,* 1980; *Viaggio delle lune,* November–December 1981, traveled to Art and Project, Amsterdam

Sperone Westwater Fischer, New York, February– March 1981

Bruno Bischofberger, Zürich, March–April 1981

Galleria Sperone, Rome, November 1981

### Selected Bibliography

BY THE ARTIST

*Disegno finto,* Rome, 1978

With Achille Bonito Oliva, *Canzone,* Modena, 1979

*Il veleno è stato sollevato e trasportato,* Macerata, 1979

With Achille Bonito Oliva and Sandro Chia, *Tre o quattro artisti secchi,* Modena, 1979

*Diciannove disegni,* Modena, 1980

ON THE ARTIST

*Newspapers and Periodicals*

Roberto G. Lambarelli, "Enzo Cucchi: Giuliana De Crescenzo/Roma and Mario Diacono/Bologna," *Flash Art,* no. 88-89, March–April 1979, p. 51

Achille Bonito Oliva, "La trans-avanguardia italiana," *Flash Art,* no. 92-93, October–November 1979, pp. 17-20

Corinna Ferrari, "Stanze del Castello," *Domus,* no. 604, March 1980, p. 55

"Italienische Kunst Heute," *Kunstforum,* vol. 39, March 1980. Special issue

Achille Bonito Oliva, "The Bewildered Image," *Flash Art,* no. 96-97, March–April 1980, pp. 32-35, 38-39, 41

Laura Cherubini, "The Rooms: Castello Colonna/ Genazzano," *Flash Art,* no. 96-97, March–April 1980, pp. 42-43

Milton Gendel, "Ebb and Flood Tide in Venice," *Art News,* vol. 79, September 1980, p. 120

William Zimmer, "Italians Iced," *The SoHo Weekly News,* vol. 8, October 8-14, 1980, p. 45

Thomas Lawson, "Chia, Clemente, Cucchi," *Flash Art,* no. 100, November 1980, p. 43

Jean-Christophe Ammann, Paul Groot, Pieter Heynen and Jan Zumbrink, "Un altre arte?," *Museumjournaal,* serie 25, December 1980, pp. 294-295

Cynthia Nadelman, "Sandro Chia, Francesco Clemente, Enzo Cucchi," *Art News,* vol. 19, December 1980, p. 193

Carrie Rickey, "New York: Sandro Chia, Enzo Cucchi and Francesco Clemente: Sperone Westwater Fischer," *Artforum,* vol. 19, December 1980, pp. 70-72

John Russell, "Critics' Choices," *The New York Times,* February 22, 1981, Section 2A, p. 3

"Wochenprogramm: . . . und zulassen, dass die Landschaften schwitzen," *Tages-Anzeiger,* Zürich, March 27, 1981

Henry Martin, "The Italian Scene, Dynamic and Highly Charged," *Art News,* vol. 80, March 1981, pp. 70-77

Roberto G. Lambarelli, "Enzo Cucchi: Emilio Mazzoli/Modena," *Flash Art,* no. 102, March–April 1981, p. 51

Joan Casademont, "New York: Enzo Cucchi," *Artforum,* vol. 19, April 1981, p. 65

Lewis Kachur, "Enzo Cucchi," *Arts Magazine,* vol. 55, April 1981, p. 13

Richard Flood, "New York: Enzo Cucchi," *Artforum,* vol. 19, May 1981, p. 69

Deborah Phillips, "Enzo Cucchi," *Art News,* vol. 80, May 1981, p. 196

Hilton Kramer, "Expressionism Returns to Painting," *The New York Times,* July 12, 1981, Section 2, pp. D1, D23

Jean-Christophe Ammann, "Westkunst: Enzo Cucchi," *Flash Art,* Summer 1981, no. 103, p. 37

René Payant, "From Landuage to Landuage," *Parachute,* Summer 1981, pp. 27-33

Achille Bonito Oliva, "Enzo Cucchi," *Domus,* no. 620, September 1981, p. 75

Jeff Perrone, "Boy Do I Love Art or What," *Arts Magazine,* vol. 56, September 1981, pp. 72-78

Jean Rouzaud and Emile Laugier, "Enzo Cucchi peint des heros et des saints pour consoler les petits hommes craintifs," *Actuel,* no. 23, September 1981, pp. 84-85

"Malerei '81: Triumph der Wilden," *Art Das Kunstmagazin,* no. 10, October 1981, pp. 32-43

*Book*

Achille Bonito Oliva, *The Italian Trans-avantgarde,* Milan, 1980

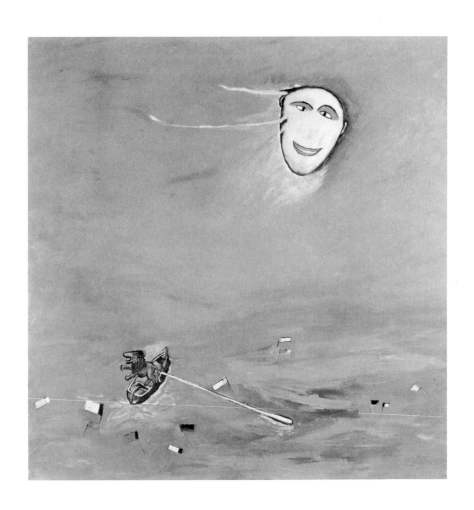

**18**
*Lion of the Seas (Leone dei mari).* 1979-80
Oil on canvas, 83½ x 82″ (212 x 208 cm.)
Collection Paine Webber Inc., New York

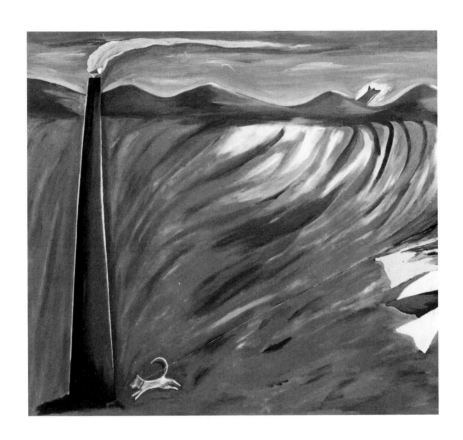

**19**
*Untitled (Red Landscape).* 1980
Oil on canvas, 79¼ x 86½″ (201.5 x 220 cm.)
Collection Stedelijk Museum, Amsterdam

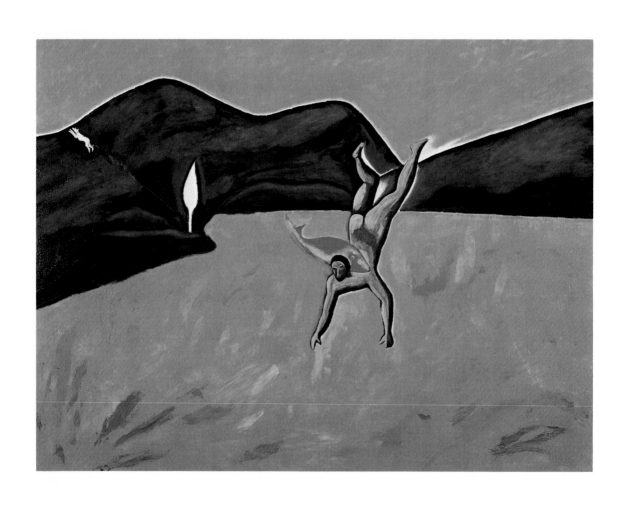

**20**

*A Fish on the Back of the Adriatic Sea (Pesce in schiena del Mare Adriatico).* 1980
Oil on canvas, 78¾ x 107½ " (200 x 273 cm.)
Collection Erich Marx, Berlin

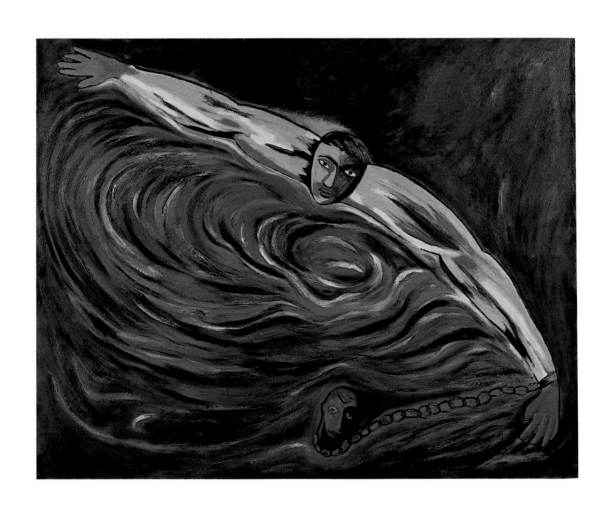

**21**
*Swimmer (Nuotatore).* 1980
Oil on canvas, 80¾ x 82¾" (205 x 210 cm.)
Courtesy Gian Enzo Sperone, Rome

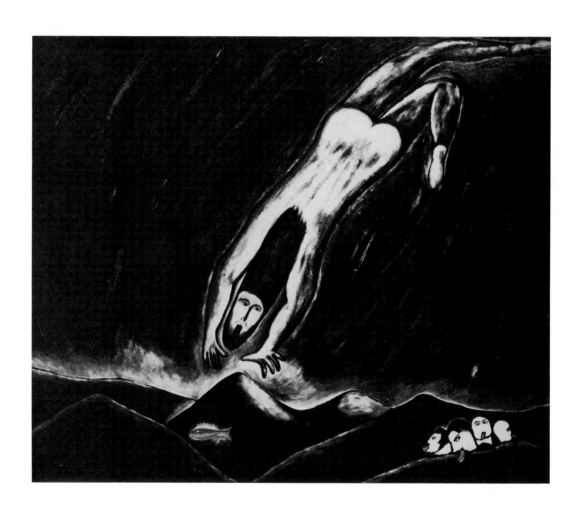

**22**
*Ferocious Tongues (Lingue feroci).* 1980
Oil on canvas, 82½ x 99½″ (210 x 252.5 cm.)
Collection Stedelijk Museum, Amsterdam

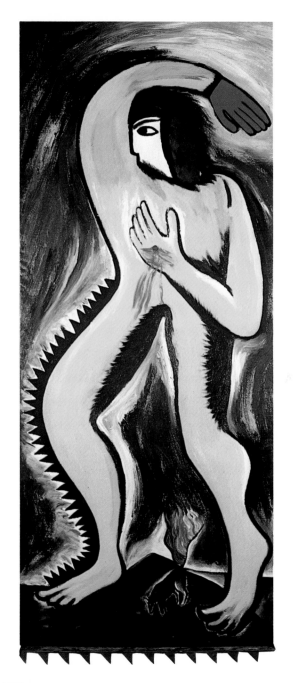

**23**
*Heroic Voyage (Viaggio eroico).* 1980
Oil on canvas with metal, 105 x 43¼ ″ (266 x 110 cm.)
Collection Stedelijk Museum, Amsterdam

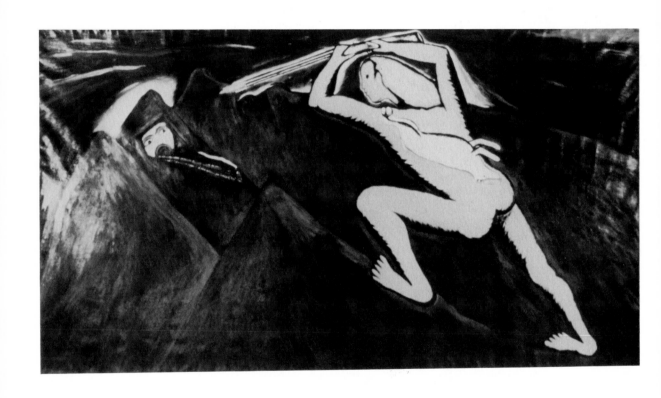

**24**
*Ferocious Painting (Quadro feroce).* 1980
Oil on canvas, 79 x 144½ ″ (200.7 x 367 cm.)
Courtesy Gian Enzo Sperone, Rome

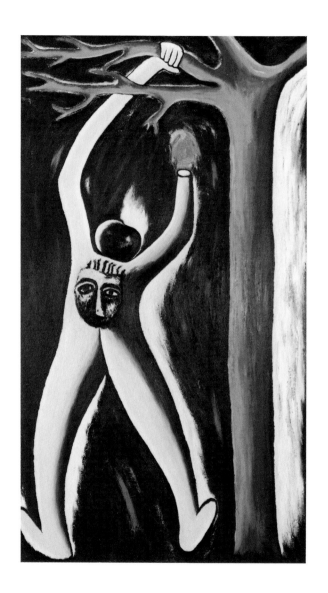

**25**
*Sacrificing Painting (Quadro sacrificante).* 1981
Oil on canvas, 94¾ x 52¾″ (240 x 134 cm.)
Courtesy Sperone Westwater Fischer, New York

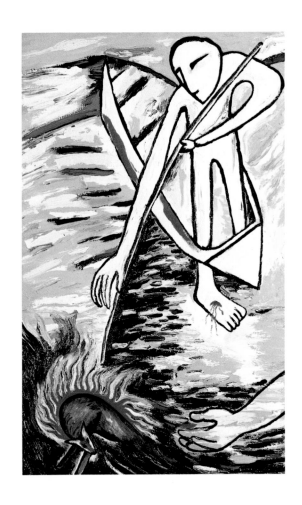

**26**
*Saint, Saint (Santo, santo).* 1981
Oil on canvas, 70¾ x 43¼ ″ (178 x 110 cm.)
Private Collection, Zürich; Courtesy Galerie Bruno
Bischofberger, Zürich

**27**
*Battle of the Regions (Battaglia delle regioni).* 1981
Black chalk on paper, 107½ x 169¼ ″ (273 x 430 cm.)
Collection Robert A. Rowan, Los Angeles

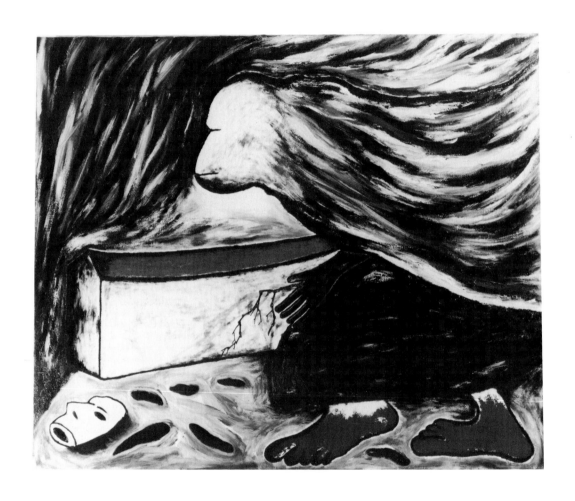

**28**
*It Must Not Be Said (Non si deve dire).* 1981
Oil on canvas, 79 x 95″ (200 x 241 cm.)
Collection Gian Enzo Sperone, Rome

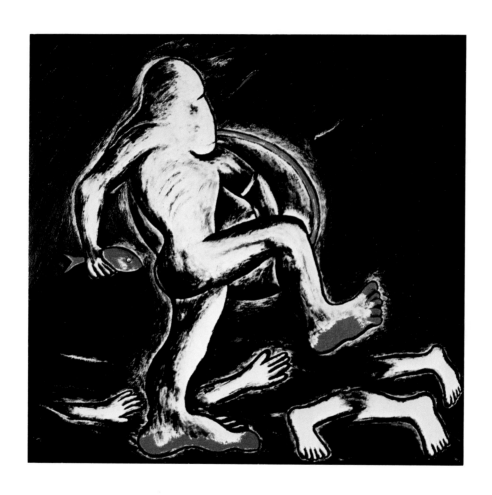

**29**

*Under the Wind (Sotto vento).* 1981
Oil on canvas, 78¾ x 80¾ ″ (200 x 205 cm.)
Private Collection, Paris; Courtesy Galerie Bruno
Bischofberger, Zürich

# Nino Longobardi

Statement by the artist

*In the first phase of my work the references were artists such as Kounellis and Paolini. In that period my work was based on a fundamental element, which was the space and the architecture of the place where the work was contained. In this sense my works were not conceived a priori, but they developed naturally from suggestions of the surrounding physical space and signs of the cultural environment in which I found myself working. For example, the exhibitions in Stuttgart, Rotterdam and Geneva were realized with this kind of procedure.*

*At the moment I'm interested in recovering a kind of painting done in the fifties (but I don't refer to anyone in particular). I like to use a painting material that, everything considered, is unpleasant, even dirty. In a way I would like to do "coffeeshop paintings," which means in absolute freedom, without controlling the final result too much, because I don't believe that a "finished" work exists. Each work has its own character that doesn't allow the identification of recognizable elements in the sense of "more beautiful" or "less beautiful." What is evident, therefore, to me is the impossibility of describing my works, which I like to invent day by day, contradicting a common concept of style: I use painting as a procedure of deprivation.*

On November 23, 1980, an earthquake of catastrophic proportions shook the southern Italian port city of Naples. Catacylsmic upheavals of nature are not alien occurrences for Neopolitans: in A.D. 63 an earthquake seriously damaged Pompeii and the eruption in A.D. 79 of Mt. Vesuvius completely buried the city. Paradoxically, the destructive volcanic ash preserved the ruins of Pompeii, and the excavation of the city in the eighteenth century revealed the remains of an ancient civilization and its art. Similarly, the recent earthquake brought positive as well as tragic consequences, for the people of Naples rose to the monumental task of reconstruction and a new vitality is today manifested in the life of the region. Nino Longobardi lost his home and studio in the earthquake, yet the disaster stimulated him to achieve a new level of creativity and has signaled a new direction in his painting.

Achille Bonito Oliva, who regards Longobardi as one of the leading young talents of the Italian Trans-avantgarde, has written about the role of catastrophe, both in its metaphorical and its literal sense, in the emergence of the Trans-avantgarde. He says that in the aftermath of catastrophe, art has the power to restore culture to a position of balance and order. On another level, he likens catastrophe to unplanned accidentality, which allows for greater artistic freedom. Catastrophe in this sense has the power to disrupt the tautological and linear development of art in favor of a non-hieratical, non-temporal movement that permits the artist to move freely within artistic and cultural history, taking inspiration from many directions and moments. Moreover, Oliva maintains that the displacement of the old artistic order by the new generation (the Trans-avantgarde) is itself a catastrophe in the most positive sense of the concept.

Longobardi's pre-earthquake production is strikingly different in character from his more recent work, and has its roots in the Conceptual Art that pervaded Italy in the early seventies. The early work was conceived according to the dictates of the installation space and shaped by the ideas this space suggested. Longobardi cites Jannis Kounellis as a significant source of inspiration for him in this period. Of particular importance for Longobardi was Kounellis's extension of the art object into real space, an extension which endows this space with the compositional fixity characteristic of painting.

Canvas is a primary component of Longobardi's installation pieces. Whereas canvas is a traditional material, the artist uses it in an untraditional manner, and thereby bestows it with a new independence: fluid, unstretched, draped, furled, unfurled, it turns corners, even moves away from the wall at a ninety-degree angle to enter the space of the room. Despite its malleability, this canvas has an architectural dimension; despite its seeming emptiness, it retains a compelling visual presence. At the Centre d'Art Contemporain in Geneva in 1980, Longobardi draped two white canvases like curtains in

front of two windows and united them with a loosely rolled canvas—an umbilical cord of sorts—which lay on the floor in front of them. At the Galerie 't Venster in Rotterdam in 1980, Longobardi elaborated with an image the ideas he had conveyed with his blank canvas. Here a canvas is tacked along the wall, angling out at one end to extend into the space of the room where it is attached to a pole; a white drapery hangs from the ceiling nearby and trails along the floor; a dog drawn on the canvas on the wall takes into its mouth the corner of the trailing drapery. The animate quality of the drawing adds an element of humor and surprise that tempers the austerity of the bare expanses of white canvas. A similar note of humor was injected into another installation at the Centre d'Art Contemporain, where a small wooden cannon was placed in a gallery. The barrel of the weapon breaks through the wall into the space of the adjoining room where it sprays shells onto a canvas propped against the wall. Thus, art is created by the firing of a gun. The ostensible violence and aggression of this act perpetrated in an aesthetic context and towards an aesthetic purpose are contradicted by the fact that the shot the cannon has fired are not artillery shells but mussel shells. In yet another installation, a real tiger skin, complete with head, is partly attached to the canvas mounted on a wall, partly draped on the floor. The tiger's stripes are continued onto the canvas by virtue of pencil marks made by the artist to effect the unlikely transition from skin to canvas, from nature to art. Thus, the pristine order and serious conceptual framework of these environments are invaded and animated by humor, by trompe l'oeil techniques and by the strange beasts that inhabit them (see cat. nos. 30-32).

Longobardi worked towards the reintegration of the image and its support, of figure and ground, an evolution that took him from the realm of installation into the realm of painting. At first, he continued to keep the image literally outside the picture space: objects, such as small boats, broomsticks, tiger skins, are affixed to the densely and turgidly painted surface of the canvas. This intrusion of objects into the realm of painting is reminiscent of Johns and Rauschenberg, two artists Longobardi admires. Gradually, he began to integrate the figures with the canvas by drawing them instead of applying them. The first dog, which took the canvas in its mouth, and the objects applied to the surfaces, existed in antithetical relationships with the paintings. Now, however, Longobardi makes his first real synthesis of figure and ground through drawing and color. His palette varies from harsh and grating high-keyed colors such as acid yellows and shrill greens to more subdued, muddied blue-grays and brownish reds. Color is never ingratiating; it is charged with emotion and speaks powerfully. The strength of this color derives in part from the density of pigment, so thick it seems almost modeled, and the large dimensions of the areas it covers. The whirlpools and vortexes of thickly applied paint, the agitated brushstrokes and strident colors portend the cataclysm of the earthquake.

Longobardi's approach to painting is visceral rather than intellectual. In fact, he refers to his canvases as "coffeeshop" or "tavern" paintings, likening them to the kind of art found in these mundane locales. He admires this genre for its ugliness, for its freedom of execution which is unconstrained by knowledge of technique, of art history and politics. He states, "I am interested in using a pictorial medium which is displeasing, even dirty."[1] Rapidity of execution is of utmost importance because it gives his work its uninhibited force and vitality. Longobardi wishes to keep his intervention in the art-making process at a minimum (for this reason, he left his earliest canvases almost bare). He speaks of the radicality of his work in this respect: "Before when one prepared a painting one was intent on controlling the dangers and risks which the work could develop, the mental elaboration was at the basis of everything. My [works] which you see are paintings without project."[2]

Longobardi exhibited a group of five highly individual canvases at the Galleria Lucio Amelio in Naples in 1980. He dedicated the works to Goya, Turner, van Gogh, Cézanne and Bacon, although he makes only indirect stylistic or thematic references to these artists in his painting. For example, he real-

izes a dialogue with Goya in a bright, mustardy yellow canvas where a shadowy bull-like form heaves a picador in the air. In another painting he appropriates material from Bacon. The focal point of the canvas, a blood-red side of beef, is incongruously juxtaposed with a religious motif, tiny figures representing the meeting of St. Francis and the wolf; the images float upon an amorphous field of silvery grey. In successive work Longobardi adopts from Bacon not only the specific imagery of the bloody carcass but also his disagreeable colors, his nightmarish vision, the atmosphere of torment and even the triptych format. He explains, "Bacon interests me because one can never know if he makes paintings for himself or for others, you can never understand if they should satisfy or irritate the executioners which they represent. Then there is the painting of Goya which made a big impression on me. His 'cunning' is fascinating: he knows how to satisfy the client without renouncing the unpleasant and the provocative."[3]

Longobardi has frequently used the image of the skull (cat. no. 40). This recurrent motif does not, as one might expect, symbolize horror and death. For Longobardi is profoundly influenced by Neopolitan tradition, and according to a local cult of pagan origin, the Cult of the Dead, the skull is revered as an image of happiness and optimism. Neopolitans traditionally select skulls as good luck symbols from the ancient grottoes of the city; they pay homage to their skulls by bringing them gifts on Sundays. Thus, in an untitled red painting by Longobardi from 1980, a rainbow arcs over the central image of the skull, reinforcing its special and affirmative meaning.

In December of 1980 Longobardi exhibited a group of works entitled *Earthquake* at the Galleria Lucio Amelio in Naples (cat. no. 36). The paintings represent a striking departure from the preceding work and reflect the impact of the earthquake on the artist. Figuration and drawing take on much greater importance here, and an overall grisaille cast replaces the dense color of the earlier canvases. An overriding sense of upheaval and disorder in nature pervades the series. This sense of nature in disarray is conveyed through the depiction of scenes of disaster, through unexpected orientation of images and dramatic and abrupt changes in their scale from panel to panel of triptychs. Thus, in the center of one triptych, Longobardi depicts the bow of a boat in its final moment of visibility before disappearing into the vortex of water which has already claimed the stern. Another panel, showing a series of eight identically nude and faceless figures standing in a row, is oriented vertically, so that the figures read as a stack (of corpses perhaps). In still another triptych, classical statuary, which appears eerily alive, has toppled over. Although not every nuance of meaning in these allegories of destruction is decipherable, the extravagant dramatic power of the paintings is inescapable. Longobardi's narrative language is deeply evocative; the drama of the particular events he depicts is underscored by imagery recalling similar devastations, not only the recent earthquake, but Pompeii and other cataclysmic events, both man-made and natural, which have shattered the order of civilization.

The apparitional, even spectral, quality of the figures in a more recent work, a diptych (cat. no. 37), relates it to the incorporeal forms of the *Earthquake* series. In the diptych the upper torso of a swimmer is repeated again and again; to the right of this obsessive series of images is an oversized seahorse. On the ground nearby is a hat covered with gesso and paint—a motif the artist uses frequently, either alone as a self-sufficient sculptural object or as part of an installation. Longobardi maintains that his images have no symbolic significance in this work: the swimmer is a figure borrowed from de Chirico; the seahorse was invented merely as a curiosity; the hat seems to have been juxtaposed with the panels only because its curlicue echoes the shape of the seahorse's tail. Indeed, Longobardi is acutely sensitive to the way forms complement each other, a sensitivity apparent in the rhythmic pattern created by the repetition of the curving arms of the swimmers and the loop of the seahorse's tail.

Drawing and painting are harmoniously integrated throughout Longobardi's oeuvre. He begins his canvases with a charcoal underdrawing which remains visible through the glaze-like color applied there-

after. Longobardi's compelling draughtmanship is apparent in the *Earthquake* series and in the diptych as well. Drawing permits the artist a dynamic spontaneity which he cherishes (he prefers to complete a work at one sitting).

In a series of recent portraits (for example, cat. no. 41) Longobardi further explores the motif of otherworldly figures introduced in the *Swimmer* and *Earthquake* paintings. The haunting faces and hollowed-out eyes of the figures in these new works recall Bacon's eyeless, distorted faces and Giacometti's mask-like portraits. The apparitional quality of their incorporeal forms is enhanced by milky, opalescent white overpainting. These beautiful shadows of reality seem in danger of dissolving, but turbulent brushwork lends them a trace of palpability which returns them to the tangible world.

Longobardi's work is richly eclectic and highly varied. He draws upon sources as diverse as Goya and Cézanne, Bacon and Twombly, finds inspiration in the art of past and present, in both cultural and personal history. His mercurial art may evoke anguish or joy, it may be primitive, violent and disturbing, or sophisticated, graceful and elegant, richly colored or subdued in tone. These characteristics do not intersect in a unified vision, for Longobardi treats each work, or each series of works, as a self-sufficient statement: together they form a kind of fever chart of his psyche.

## Footnotes

1. Bonuomo, *Il Mattino*, December 1980. Translated by Shara Wasserman
2. Ibid.
3. Ibid.

## Selected Group Exhibitions

Galleria Lucio Amelio, Naples, *Rassegna della nuova creatività nel Mezzogiorno*, February–March 1979; *8 gennaio 80*, January 8, 1980

Galerie Paul Maenz, Cologne, *Arte Cifra*, June 1979. Catalogue with text by W. Max Faust and Paul Maenz

Kunstmarkt Basel, *Perspective '79: Art 10 '79*, June 1979

Stuttgart, *Europa 79*, September–October 1979

Städtische Galerie im Lenbachhaus, Munich, *Nino Longobardi und Ernesto Tatafiore*, March 1980. Catalogue with text by Helmut Friedel

Palazzo della Triennale, Milan, *Nuova immagine*, April–July 1980. Catalogue with text by Flavio Caroli

Centre d'Art Contemporain, Geneva, *7 juin 1980*, June 7, 1980. Catalogue with text by Fulvio Salvadori

Spoleto, *Incontri 1980*, June–July 1980

Galleria Nazionale d'Arte Moderna, Rome, *Arte e critica 1980*, July–September 1980. Catalogue with text on Longobardi by Flavio Caroli

Galerie Schellmann und Klüser, Munich, *Nino Longobardi und Ernesto Tatafiore*, 1980

Palazzo delle Esposizioni, Rome, *Linea della ricerca artistica in Italia 1960/1980*, February–April 1981. Catalogue

São Paulo, *XVI Bienal de São Paulo*, October 1981

Musée d'Art Moderne de la Ville de Paris, *Baroques 81*, October–November 1981. Catalogue with text by Cathérine Millet

Galerie Heiner Heppe, art in progress, Düsseldorf, *Futura fett: Herbert Bardenheuer, Nino Longobardi*, January–March 1982

Mura Aureliani, Rome, *Avanguardia e transavanguardia*, February–March 1982. Catalogue with text by Achille Bonito Oliva

## Selected One-Man Exhibitions

Studio Gianni Pisani, Naples, December 1977–January 1978

Galerie Paul Maenz, Cologne, July 1978

Galleria Lucio Amelio, Naples, February 1979; December 1980. Catalogue with text by Lucio Amelio, Achille Bonito Oliva and Michele Bonuomo

Marilena Bonomo, Bari, November 1979

Galerie 't Venster, Rotterdam, May 1980

Galleria De Crescenzo, Rome, March–April 1981. Catalogue with text by Achille Bonito Oliva

Galerie Fina Bitterlin, Basel, October 1981

Internationaler Kunstmarkt, Cologne, *Förderprogramm für junge Kunst*, October 1981

## Selected Bibliography

ON THE ARTIST

*Newspapers and Periodicals*

Vitaliano Corbi, "Gli ambienti di Longobardi," *Il Mattino*, March 8, 1979

Giulio De Martino, "Arte: il risentimento dell'artista dequalificato—nuova creatività: una mostra a Napoli," *Manifesto,* April 24, 1979

Annemarie Monteil, "Zukunft aus Italien: Perspective '79," *Basler Zeitung,* no. 137, June 15, 1979 p. 47

Jürgen Hohmeyer, "Kunst Klotz gemalt," *Der Spiegel,* no. 42, October 15, 1979, pp. 238-239

Peter M. Bode, "Liebe zu Magie und Sachlichkeit," *Münchener Abendzeitung*, March 10, 1980, p. 11

Jürgen Morschel, "Quax war da," *Süddeutsche Zeitung*, March 19, 1980

Renato Barilli, "Il pennello va in barchetta," *L'Espresso*, May 11, 1980, p. 139

Arcangelo Izzo, "L'artista impollinato," *La Voce della Campania*, May 11, 1980, p. 54

Lucio Amelio, "Splende l'arte italica," *Il Mattino*, May 22, 1980

Fulvio Salvadori, "Nino Longobardi," *Art Press*, no. 37, May 1980, p. 11

Michele Bonuomo, "Bianco e rosa: Spoleto a striscie," *Il Mattino Illustrato*, no. 32, August 9, 1980, pp. 17-27

"Trip around world with General Idea," *File Magazine*, vol. 4, summer 1980, pp. 41-45

Flavio Caroli, "L'arte ridiscende nel profondo," *Corriere Della Sera Illustrato*, October 18, 1980

Francesco Vincitorio, "Intervista con Flavio Caroli," *L'Espresso*, November 2, 1980

Christoph Schenker, "Begegnungen 1980: 20 Installationen Zeitgenössischer Künstler in Spoleto," *Kunstforum International*, vol. 39, fall 1980

Giulio De Martino, "Una mostra di Longobardi a Napoli," *Manifesto*, December 18, 1980

Michele Bonuomo, "Questo quadro lo dedico a me," *Il Mattino*, December 20, 1980

Maria Di Domenico, "Il colore dell'inconscio," *Paese Sera*, January 2, 1981

Enzo Battarra, "Nino Longobardi esalta superfici," *Paese Sera*, January 9, 1981

Arcangelo Izzo, "Nino Longobardi," *Flash Art*, no. 102, March–April 1981

Barbara Tosi, "Nino Longobardi," *Segno*, no. 21, May–June 1981

Siegmar Gassert, "Nino Longobardis Anspielungen," *Basler Zeitung*, no. 234, October 7, 1981, p. 39

Severo Sanduy, "Un art monstre," *Art Press,* October 1981, pp. 7-8

Antonio D'Avossa, "Nino Longobardi," *Flash Art*, no. 105, December 1981

*Book*

Lucio Amelio, Achille Bonito Oliva and Michele Bonuomo, *Tony Cragg, Nino Longobardi, Mimmo Paladino, Joseph Beuys, Ernesto Tatafiore, David Salle: Lucio Amelio Napoli 1980/81*, Naples, 1981

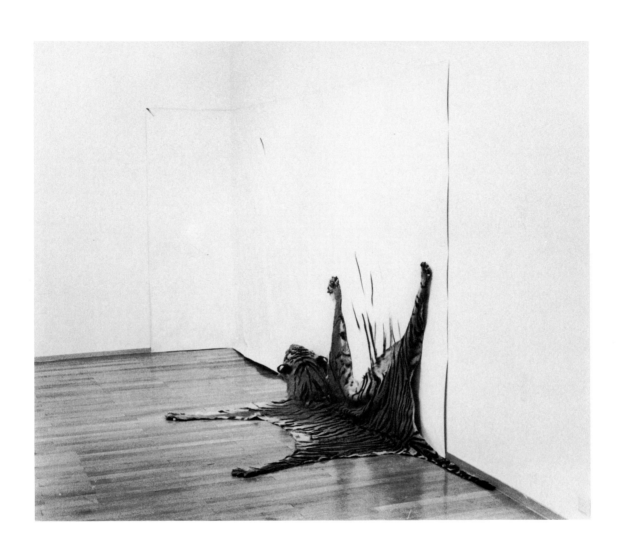

**30**
*Untitled (Senza titolo).* 1979
Tiger skin, charcoal and canvas, 78¾ x 197 x 39¼″
(200 x 500 x 100 cm.)
Private Collection, Stuttgart

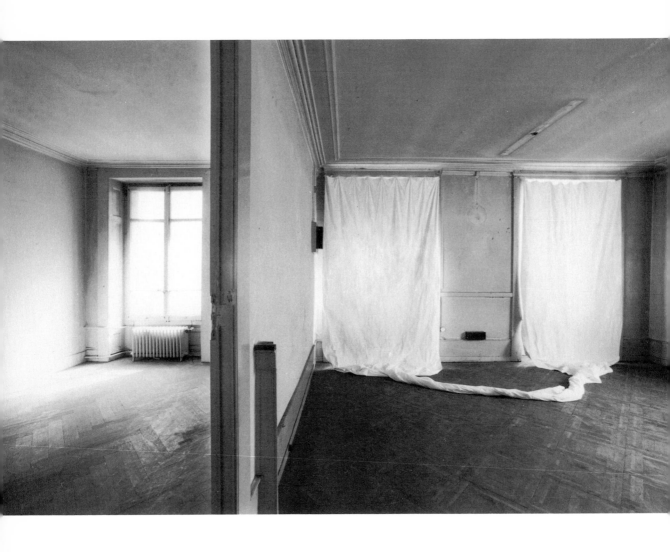

**31**
Installation
Canvas
Centre d'Art Contemporain, Geneva, February 1980

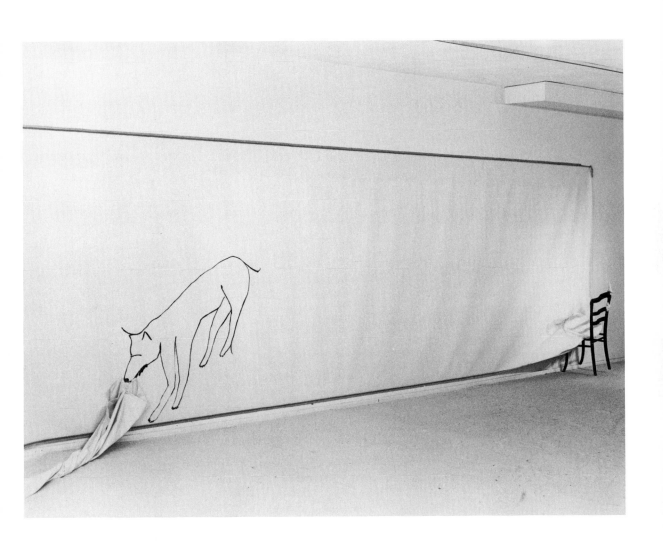

**32**
Installation
Wood objects, charcoal and canvas, 78¾ x 393¾ ″
(200 cm. x 10 m.)
Galerie 't Venster, Rotterdam, March 1980

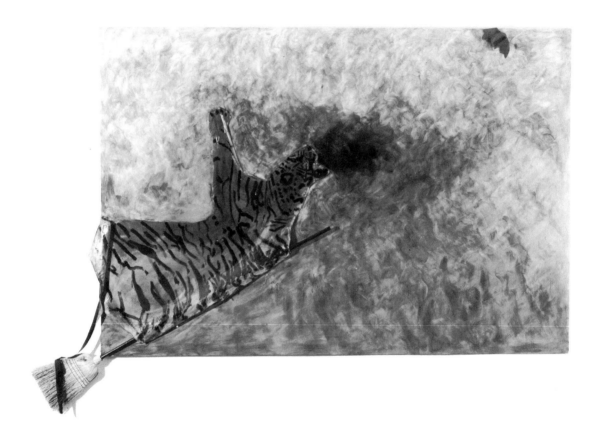

**33**

*Untitled (Senza titolo).* 1980
Oil and mixed media objects on canvas, 90½ x 134″
(230 x 340 cm.)
Private Collection, Naples

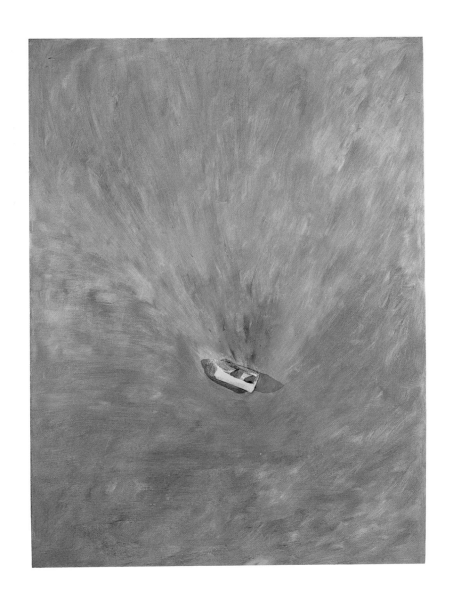

**34**
*Untitled (Senza titolo).* 1980
Oil and object on canvas, 102 x 78¾"
(260 x 200 cm.)
Private Collection, Munich

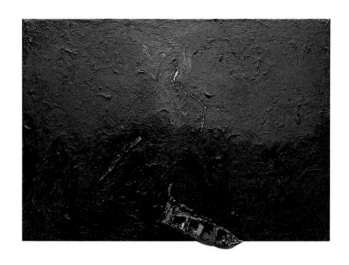

**35**
*Untitled (Senza titolo).* 1980
Encaustic and object on canvas, 10 x 12¾ ″
(40 x 50 cm.)
Private Collection, Stuttgart

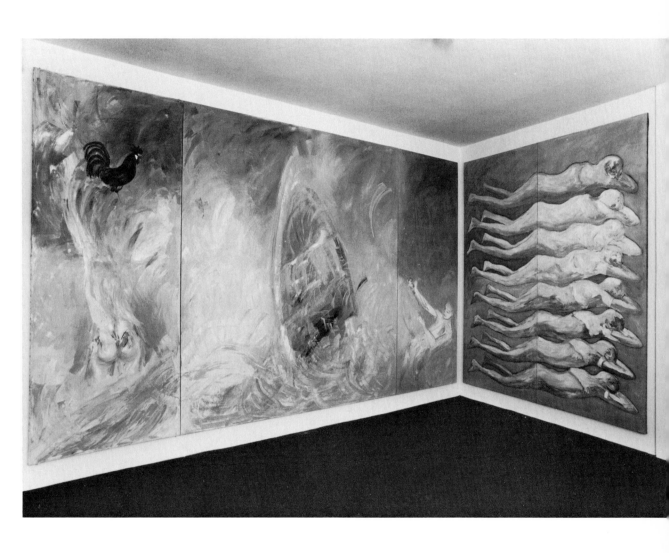

**36**
*Earthquake (Terremoto)* (detail). 1980-81
Oil on canvas, four panels, total 89 x 444½″
(350 cm. x 11.29 m.)
Courtesy Galleria Lucio Amelio, Naples

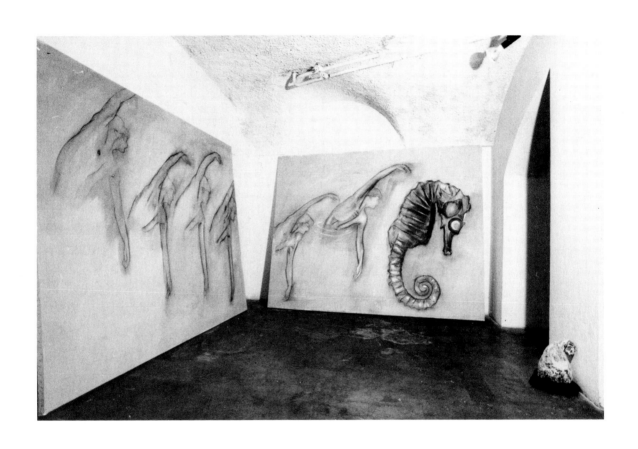

**37**
*Untitled (Senza titolo).* 1981
Oil and charcoal on canvas with object, two panels,
each 78¾ x 102″ (200 x 260 cm.)
Courtesy Giuliana De Crescenzo, Rome

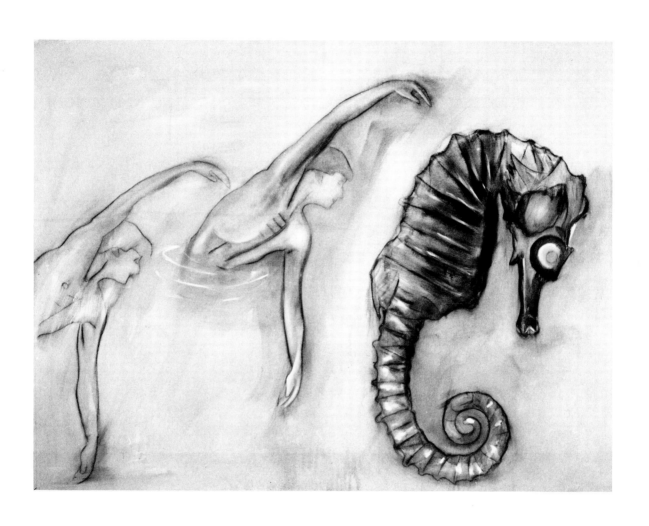

**37**
Detail

**38**
*Untitled (Senza titolo)*. 1981
Oil on canvas, 50¾ x 76¼ ″ (200 x 300 cm.)
Courtesy Galleria Lucio Amelio, Naples

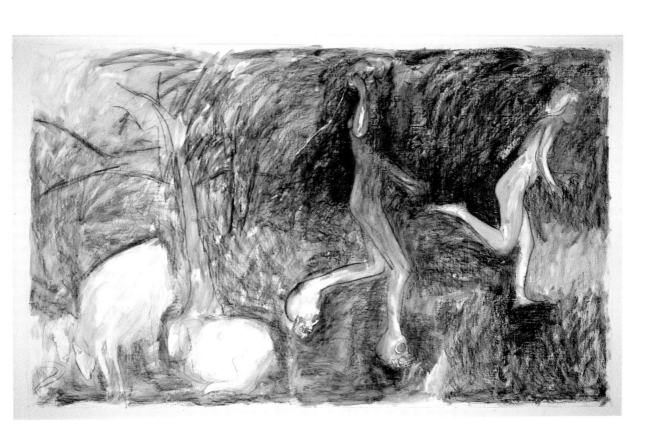

**39**
*Untitled (Senza titolo).* 1981
Tempera and charcoal on paper, 61 x 114¼″
(240 x 450 cm.)
Courtesy Galleria Lucio Amelio, Naples

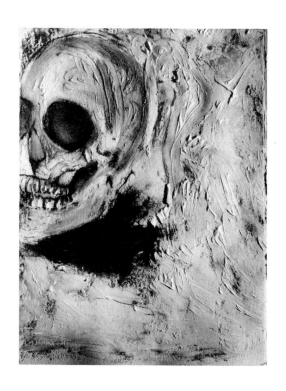

**40**
*Untitled (Senza titolo).* 1981
Tempera on paper, 19¼ x 14½″ (76 x 57 cm.)
Courtesy Galleria Lucio Amelio, Naples

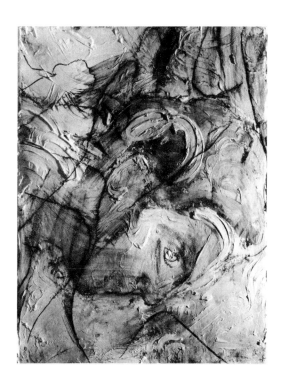

**41**
*Untitled (Senza titolo).* 1981
Tempera on paper, 19¼ x 14½ ″ (76 x 57 cm.)
Private Collection, Naples

# Luigi Ontani

Born in Vergato
Moves to Rome, 1970
Visits Madras, Jaipur and Benares, India, 1974
Returns to India, 1975, 1976, 1977, 1978
Lives and works in Rome

Luigi Ontani reincarnates his favorite heroes from mythology, folklore and fairytales, history and art history by using his own body as the instrument of communication. He assumes the identities of these legendary figures by donning their clothes and attributes. This metamorphosis is effected in the real space of his performances and tableaux-vivants, in the transcribed space of his photographs and films, in his poetic writings and, most recently, in his agile and graceful pen and ink drawings and watercolors. In all these media Ontani himself is subject and object; this extreme kind of self-portraiture is not, however, ostentatious or narcissistic. Narcissus projects himself outside his body in order to love what is inside himself; Ontani projects himself into the persona of another in order to create art, to live art, to express his love for art. He says that the mirror of art is his mirror, the self-portrait is not only him but all of art.

Ontani has achieved what is for him an ideal integration of art and life: he lives his art, and his art is his life. In adopting his disguises, he absorbs the identity of another, at once losing and rediscovering himself. Similarly, his identification with the persona of fiction or history disguises neither himself nor the other persona—it creates, rather, an ideal symbiosis of the two.

We meet the artist's individual fantasies in his re-incarnations. Though most of Ontani's figures are based in his Italian cultural heritage, his repertory is wide-ranging and immense, drawn from literature (Dante, William Tell, Don Quixote, Don Giovanni), the Bible (Adam and Eve, David and Goliath, the Angel of the Annunciation), mythology (Narcissus, Onan, Bacchus, Hermaphrodite), comic strips (Superman), history (Christopher Columbus), Italian folklore (Pulcinella, Pinocchio). He also does a series he calls "d'après," versions of famous works in the styles of their originators (Guido Reni's *St. Sebastian*, Joseph Cornell's *Medici Prince*, Mondrian's *Broadway Boogie-Woogie*). Ontani executes these with accuracy and creativity, referring to written descriptions, original paintings or photographs to insure their verisimilitude.

Ontani's earliest works were small objects constructed of quasi-technological materials, such as corrugated cardboard or colored styrofoam, which were placed in space in arrangements suggesting disorder and precarious equilibrium. This sense of disarray and the fanciful nature of the objects contributed an element of freshness and innocence to the installations: they made one think of toys left scattered on the floor after a child had finished playing with them. Ontani was to preserve this sense of childlike innocence and naiveté throughout his oeuvre, even though his means of expression changed radically.

Next Ontani began to reinterpret figures from the past by costuming his own body, which he had photographed; the photograph thus stood as the work of art. However, the tableau-vivant, the sustained pose, soon became his preferred medium of re-creation. Tableaux-vivants are by definition static, yet Ontani infused his with a dynamism that flowed from his choice of subject, the implied interaction between figure and environment, and his unique synthesis of the serious and the playful.

As a painter reaches into art history or mythology to nourish his own art, interpreting these borrowings in a personal way to create his own work, so Ontani brings to bear on his tableaux-vivants the borrowing of an identity. And Ontani confronts the same formal issues that engage the painter: color, light, scale and composition. Ontani's finished work, like the finished painting, depends not only upon the creativity of the artist but also upon the associations, memories and personal fantasies the spectator brings to the viewing experience.

The tableau-vivant, being static, does not develop; it has neither beginning nor end. Ontani believes that art has an eternal presence, and thus should assume a non-temporal structure. This structure may be likened to the timeless dimension of dreams,

where figures float back and forth, appear and disappear without regard for rational thought and order. Not only linear but historical time as well ceases to exist for Ontani. He regards myth, fable and history from a contemporary, personal point of view, so that he does not copy the subject, but rather re-creates, reinterprets and recycles it. Once recycled, the story becomes an actual event and thus lives a parallel existence with its original incarnation.

Time also does not exist for Ontani, because he never finishes his works, but recycles them within the context of his oeuvre, returning people to his wonderful miniature books, journals or diaries of his imaginative re-creations. He combines characters from different eras and media, creating new contexts that add compelling dimensions to the original images.

Ontani first appeared in public in 1973 at his exhibition at Contemporanea in Rome: he was dressed as Tarzan in a blond wig and a minute jungle-printed loincloth. He read Tarzan stories aloud, and a tape machine beside him supplied the cries of wild animals. His most concentrated performance activity took place at the Galleria L'Attico in Rome from 1974 to 1976, when he enacted Don Quixote de La Mancha, Don Giovanni, Superman and Dracula, to name a few. He reinforced his identity as Dracula by performing this piece between sunset and sunrise, the hours to which this character confined his activity.

Ontani's reincarnations are voyages of sorts, visits to other lands, cities and cultures under assumed identities. However, real travel has been an important impetus for Ontani's art. He considers a voyage to be a creative experience in itself. He distinguishes between the experience as a work of art and the souvenirs of the voyage as the traces of that experience. Between 1974 and 1978 Ontani made five excursions to India—voyages that revealed myths to feed his art and ignited an incandescent fantasy that led him more than ever to live the life of the images he re-created. His Indian travels tinged his already delightful imagination with an exoticism that continues to nourish his art. The journeys cul-

minated in the creation of an assemblage of autobiographical photographs, En route vers l'Inde (cat. no. 48), presented at the 1978 Venice Biennale. These photographs show Ontani dressed in Oriental fashion, in beautiful silk pyjamas, embroidered tunics, turbans fashioned by India's most skilful tailors. Ontani tints his photographs according to an antique process, developed long before the invention of color film, painting areas and conferring on them the patina of age. He uses a feast of exotic colors—emerald greens, turquoises, cobalt blues and purples—which evoke the marvelous atmosphere of the land of his travels. And two new characters enter his repertory: Shiva and Krishna, gods of a thousand arms and a thousand faces.

The experience of coloring photographs encouraged Ontani to explore a new realm, that of drawing. His drawings are characterized by minute and highly detailed execution, graceful calligraphy, pastel yet luminous colors and lightness of mood. Ontani brings to all his work a painter's sensibility, for balance of color and clarity of tone are of utmost importance to him. A heightened luminosity pervades even his smallest drawings. For example, the pages of a book executed in India are hand-colored with a high-key shocking pink. Even in his juxtapositions of photographs for catalogue layouts he manipulates color to dramatic and powerful effect. Thus, in the present catalogue the intense red of Dante's garb abuts the stark black and white of Pinocchio's costume in Dante and Pinocchio (cat. nos. 42, 43). Iconography, as in the past, is culled from various epochs and summarizes or recovers private myth but is now projected onto paper through drawing. As always, the recognizable subjects are reinvented in an explicitly personal way: for example, Ontani depicts himself as the main protagonist in The Flagellation of Christ (cat. no. 54). Other drawings show a pagan paradise on earth with figures engaged in playfully sexual and other pleasurable activities. The Three Graces, another of Ontani's favorite themes, is the subject of thirty-one watercolors and two photographs, each expressing a different interpretation of the three goddesses who enhanced the enjoyment of life. Thus,

Ontani mummifies the goddesses in one work and casts them in the guise of fantastic creatures that are Boschian yet innocent in another (cat. nos. 56, 49). Ontani does not abandon the tableau-vivant format for drawing, for he treats both as different manifestations of a similar expression and believes that the passage from one medium to another is only a matter of perception. Indeed, his tableaux-vivants dating from the late seventies are among his most inventive.

Ontani's images are often born on the occasion of an exhibition. The persona in such instances is suggested to him by the space or the associations of the geographic location in which he is showing. Thus, at his first one-man show in New York at the Sonnabend Gallery in 1977, he presents Renaissance painting as interpreted by the American artist Joseph Cornell (cat. no. 47). A slide of a checkerboard floor is projected onto the gallery floor, conveying the notion of perspective as invented in the fifteenth century. Similarly, projected onto the wall is a slide of a typical Renaissance landscape. The artist stands virtually nude, sporting only a red cap and holding a toy gun, next to the landscape, with a nude figure from a Renaissance painting projected onto his body. On both formal and conceptual planes, Ontani's large collaged images parallel the levels of the tiny images in Cornell's own small, exquisite boxes and collages. Thus, through a thoughtful layering of iconographies, Ontani pays homage to Cornell's Medici Princes.

Ontani selects the theme of the Astronaut (cat. no. 46) for his American performance at the Kitchen Center in New York in 1979. In this static simulation of a space flight, Ontani wears only a large white donut-shaped helium tube around his waist and a transparent space helmet on his head. Projected onto the walls around him are slides of spaceships, of planetary bodies (including Saturn, whose rings echo the one that encircles the artist's waist), of the paintings of Creti and de Chirico (to lend a Neoplatonic and metaphysical dimension). Films featuring late Italian Renaissance paintings were shown, and the event was accompanied by the music of Verdi and Puccini.

Also in 1979 Ontani produced a complex installation entitled *Pentagonia* (cat. no. 51) at the Galleria Mario Diacono in Bologna. Here, for the first time, photographs in object-like three-dimensional geometric frames are substituted for the human body as subject matter. In another interesting departure from the tableau-vivant format, Ontani exhibited *Self-Portrait of Gilded Paper Patterns* (cat. no. 52) at Mario Diacono in 1981. The "portrait" was comprised of thirty-five patterns for his clothing, devised by his sister Tullia, which were fastened to the wall with dressmaker's pins. Ontani decorated these patterns like sacred objects, bedecking them with a myriad of gilded figures, vaguely suggestive of hieroglyphics. Despite the absence of the literal image or presence of the artist, autobiography is strongly felt in this work.

One of the primary delights of Ontani's work in all media is supplied by his whimsical use of scale. He amuses himself and the reader by his playful and unexpected manipulation of proportion and orientation in his miniature books. Thus, the orientation of imagery is always shifting, the scale of figures jumps from page to page, writing runs over the paper diagonally or races up margins. Similarly, the tableaux-vivants incorporate photographs of many different sizes taken at various distances, and images projected by slides showing an extraordinary range of focus, amplification and distortion. The dimensional leaps of his images parallel the metamorphoses of Ontani's body; both confuse the viewer, contributing to the ambiguity the artist consciously cultivates.

Ontani describes his work as "the adventure I live as a person of art," and, indeed, to experience his work is to partake of that adventure. He integrates the use of his body, the exoticism of the Orient, and the world of fact and fantasy into a lyric statement that is suffused with a childlike naiveté, an almost angelic innocence. He wears a variety of masks, but they are always beautiful. Though his artistic statement is serious, his wit and humor transport it into the realm of the charming and delightful. Like a child who is captivated by the magic of myth and fables, so Ontani travels through his own personal mythology with uninhibited pleasure.

## Selected Group Exhibitions

Centrer Za Umetmost, Novisad, Yugoslavia, 1973

Festival d'Aprile, Belgrade, 1973

Museum am Ostwall, Dortmund, *Photomedia,* March–April 1974. Catalogue with text by Daniela Palazzoli

Galleria Marconi, Milan, *La ripetizione differente,* October 1974. Catalogue with text by Renato Barilli

Kunstmuseum Luzern, *Transformer: Aspekte der Travestie,* November 1974. Traveled to Museum Bochum, Germany, February–March 1975. Catalogue with text by Jean-Christophe Ammann

Max Protetch Gallery, New York, *Italian Avant-Garde,* November 1974

Belgrade, *Festival Expended Media,* 1974

Galerie Im Taxipalais, Innsbruck, *Selbstporträt als Selbstdarstellung,* October 1975. Catalogue with text by P. Weiermaier

Jerusalem Museum, 1975

Galleria Municipale d'Arte Moderna, Turin, *1960-1977: Arte in Italia,* May 1977. Catalogue with texts by Francesca Alinovi, Renato Barilli, Antonio Del Guercio and Filiberto Menna

Galleria d'Arte Moderna, Bologna, *Settimana internazionale della performance,* June 1977. Catalogue with texts by Francesca Alinovi and Renato Barilli.

Venice, *La Biennale di Venezia: Dalla natura all'arte, dall'arte alla natura,* June 1978. Catalogue with text by Lara-Vinca Masini

Galleria d'Arte Moderna, Bologna, *Dieci: anni dopo: i nuovi nuovi,* opening March 15, 1980. Catalogue with texts by Francesca Alinovi, Renato Barilli and Roberto Daolio

Galleria Ugo Ferranti, *Artemesia,* May 1980. Catalogue with text by Achille Bonito Oliva

Pinacoteca Comunale e Museo Civico, Ravenna, *Tutte le arti tendono alla performance,* May 1980. Catalogue with text on Ontani by Francesca Alinovi

Kunsthalle Basel, *Sandro Chia, Francesco Clemente, Enzo Cucchi, Nicola De Maria, Luigi Ontani, Mimmo Paladino, Ernesto Tatafiore,* May–June 1980. Traveled to Museum Folkwang, Essen; Stedelijk Museum, Amsterdam. General catalogue with texts by Jean-Christophe Ammann, Achille Bonito Oliva and Germano Celant; supplementary catalogue on Ontani with text and drawings by the artist

Holly Solomon Gallery, New York, *The Italian Wave,* June 1980. Catalogue with text on Ontani by Francesca Alinovi

Palazzo Mazzancolli Terni, *Bestiario,* June–July 1980. Catalogue with text by Silvana Sinisi

Padiglione d'Arte Contemporanea, Ferrara, *La qualità: sviluppo dei nuovi nuovi,* May–June 1981. Catalogue with texts by Francesca Alinovi, Renato Barilli and Roberto Daolio

Galleria Nazionale d'Arte Moderna, Rome, *Arte e critica 1981,* July–October 1981. Catalogue with text on Ontani by Silvana Sinisi

Chiesa di Sant'Antonio and Biblioteca Comunale, Taormina, *Taormina fin de siècle,* September–October 1981. Catalogue with text by Italo Mussa

Galleria Graziano Vigato, Alessandria, *Al di la' della soglia,* November 1981. Catalogue with text by Marisa Vescovo

## Selected One-Man Exhibitions

Centro Culturale, San Fedele, Milan, *La stanza delle similitudini: oggetti pleonastici,* January 1970. Catalogue with text by Renato Barilli

Galleria Diagramma, Milan, and Palazzo Diamanti, Ferrara, *Teofania (spazio teofanico),* 1970-1971

Galleria Flori, Florence, January 1971

Contemporanea, Rome, *Tarzan,* 1973-74

Modern Art Agency, Naples, *Pulcinella,* March 1974

Galleria L'Attico, Rome, *Don Quixote de la Mancha, Don Giovanni, Superman,* November 1974; *Dracula,* January 1975; *Sia la luce, Gibigianna / Alnus, Boogie Woogie,* February 1976; *En route vers l'Inde,* May 1978

Lp. 220, Turin, *Gianduja,* November 1974

De Appel, Amsterdam, *Grillo,* November–December 1975

Galerie Ileana Sonnabend, Paris, *L'Indifférent,* May 1976

Galleria Sperone, Milan, *Gentiluomo con tricorno,* November 1976

Galleria d'Arte Moderna, Bologna, *Endimione,* June 1977

Koepelzaal, Amsterdam, *Muzikale Hel,* July 1977

Sonnabend Gallery, New York, *Medici Prince,* September 24–October 1, 1977

Franz Paludetto, Turin, *Evangelista,* December 1978

Galleria Mario Diacono, Bologna, *Pentagonia,* May–June 1979. Catalogue with text by Mario Diacono

The Kitchen Center, New York, *Astronaut,* November 1, 1979

71

A Space, Toronto, *Dedicated to Lucius Richard O'Brien,* December 16, 1979

Palazzo Ducale, Appartamento Doge, Genoa, *Zefiro,* 1979

Galleria Lucio Amelio, Naples, May 1980

Massimo Minini, Brescia, October–December 1980

Galleria Mario Diacono, Rome, February 1981; March 7-31, 1981

Massimo Minini, Milan, February 1981

Eva Manzio and Elena Prön, Turin, May 1981

## Selected Bibliography

BY THE ARTIST

*Composizione,* Galleria Ferrari, Verona Le Arti, Milan, 1970

"Luigi Ontani," *Flash Art,* no. 44-45, April 1974, p. 11

*Poesiae Adulescientiae,* Franz Paludetto, Turin, 1974

"Romanticismo post concettuale," *Flash Art,* no. 78-79, November–December 1977, p. 29

*Acervus,* Dacic, Tübingen, 1978

ON THE ARTIST

*Newspapers and Periodicals*

Nivo Suri, "Milano e la sua attività stagionale," *D'Ars,* January/February 1970

Tommaso Trini, "Mostre d'inverno a Milano," *Domus,* no. 483, February 1970, p. 50b

Giuse Benignetti, "Lettera da Firenze," *D'Ars,* March 1971

"Fotografia e comportamentismo," *Progresso Fotografico,* no. 3, March 1974

Valerio Riva, "Avanguardie/Body Art/Nudi alla Cometa," *L'Espresso,* no. 21, May 26, 1974

Benjamin Forgey, "Six Italian Avant-Garde Artists Who Ponder the Paradox of Time," *Star News,* Washington, D.C., October 18, 1974

Gianni Contessi and Luigi Ontani, "Nuovo Manierismo," *Data,* no. 13, Fall 1974

Luca Maria Venturi, "Nuovi Artisti," *Data,* no. 14, Winter 1974

"Special on Photoworks," *Flash Art,* no. 52-53, February–March 1975, p. 46

Umberto Eco, "Corpo e concetto artista perfetto," *L'Espresso,* Rome, March 30, 1975

Werner Lippert, "Das Selbstporträt als Bildtypus," *Kunstforum International,* no. 14, March 1975, pp. 99-124

Corinna Ferrari, "Don Quixote de la Mancha," *Casabella,* no. 401, May 1975, p. 14

Luigi Paola Finizio, "Dal corpo al concetto," *D'Ars,* vol. 16, May 1975

"Luigi Ontani," *Flash Art,* no. 54-55, May–June 1975, p. 13

Bruno Corà, "24 ore su 24," *Data,* no. 15, Spring 1975, pp. 2-5

Achille Bonito Oliva, "24 ore su 24," *Studio International,* no. 190, September–October 1975, pp. 154-155

Achille Bonito Oliva, "Spazio a tempo pieno," *Casabella,* November 1975

Achille Bonito Oliva, "Process, Concept and Behaviour in Italian Art," *Studio International,* no. 191, January 1976, pp. 3-10

Caroline Tisdall, "Performance Art in Italy," *Studio International,* no. 191, January 1976, pp. 42-45

Renato Barilli, "Oggi espone Alambicchi," *L'Espresso,* Rome, December 5, 1976

Edit De Ak, "Luigi Ontani: Sonnabend Gallery, New York," *Artforum,* vol. 16, December 1977, pp. 61-62

Valentin Tatransky, "Luigi Ontani: Sonnabend Gallery, New York," *Arts Magazine,* vol. 52, December 1977, p. 16

Francesco Vincitorio, "Pentagonia," *L'Espresso,* no. 23, Rome, June 1979

Joseph Masheck, "Neo-Neo," *Artforum,* vol. 18, September 1979, pp. 40-48

Attanasio Di Felice, "Luigi Ontani: The Kitchen/ New York," *Flash Art,* no. 94-95, January–February 1980, p. 51

Francesco Vincitorio, "Ontani," *L'Espresso,* Rome, March 1980

Francesca Alinovi, "L'arte mia," *Iterarte,* June 1980

Francesca Alinovi, "D'arte vestito," *Domus Moda,* October 1980

Francesca Alinovi, "Luigi Ontani," *Flash Art,* no. 100, October–November 1980

Jean-Christophe Ammann, Paul Groot, Pieter Heynen and Jan Zumbrink, "Un altre arte?," *Museumjournaal,* serie 25, December 1980, pp. 288-289

Jean-Christophe Ammann, *Skira Annuel,* Geneva, 1980

Italo Mussa, "Le avventure della pittura nella nuova scuola romana," *Flash Art,* no. 103, May 1981, p. 43

Italo Mussa, "Luigi Ontani: Mario Diacono/Roma," *Flash Art,* no. 103, May 1981, p. 54

*Books*

Renato Barilli, "Le ricerche di comportamento," *I problemi di Ulisse,* Florence, 1973

*Catalogo nazionale Bolaffi d'arte moderna no. 9, segnalati Bolaffi 1974: 50 artisti scelti da 50 critici,* Turin, 1973, pp. 106-107

*Returned to Sender, Informazioni 2,* Galleria Schema, Florence, February–March 1974

Lea Vergine, *Il corpo come linguaggio,* Milan, 1974

Barbara Reise, *So-Called Conceptual Art,* London, 1975

Achille Bonito Oliva, *Drawing—Transparence,* Macerata, 1976

Achille Bonito Oliva, *Europa/America,* Milan, 1976

Francesca Alinovi, "L'Ombrofago," *La fotografia: illusione o rivelazione,* Bologna, 1980

VIDEO AND FILM PERFORMANCES BY THE ARTIST

Contemporanea, *Mapa '72,* Rome, 1970-72

Galleria Schema, Florence, 1970-72

Gerry Schum, Venice, 1970-72

Studio Bentivoglio, Bologna, 1970-72

Studio STS, Rome, 1970-72

*Festival dei due mondi,* Spoleto, 1971

Centro sperimentale di Brera, Milan, 1976

8 MM. FILMS BY THE ARTIST

*Color voglia; Deserto; Fuochino; Lavaggio; Montovolo; Neo; Occhio pineale; Onfalo; Sacco e ombrello; Spirito di patate; Svenimenti; Tetto*

**Ontani has designed the following pages.**

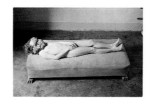

44  *Bacchus (Bacchino).* 1973   Life-size photograph by Cesare Bastelli   39⅜ x 78¾" (100 x 200 cm.)
Collection Franz Paludetto, Turin

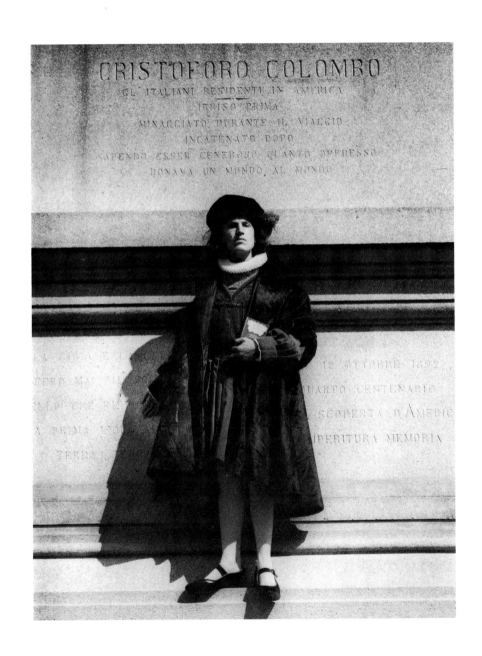

**45**  *Christopher Columbus (Cristoforo Colombo).* 1975  Life-size photograph by Gwenn Thomas
39⅜ x 27⁹⁄₁₆″ (100 x 70 cm.)  Collection Fabio Sargentini, Rome

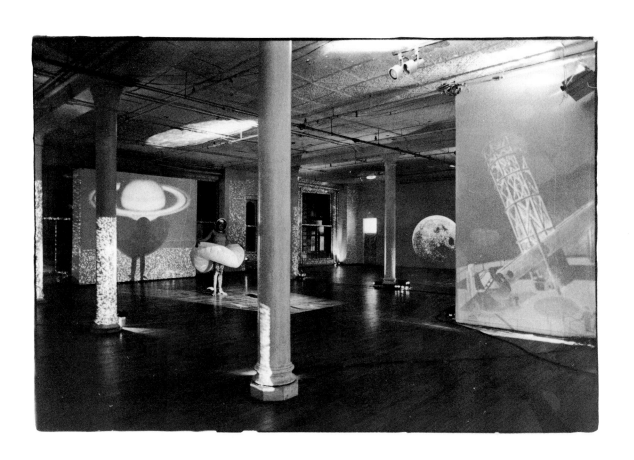

**46**  *Astronaut.* 1979  Tableau-vivant  Installation view, The Kitchen Center, New York, November 1, 1979

**47** *Medici Prince.* 1977   Tableau-vivant after Joseph Cornell   Installation view, Sonnabend Gallery, New York, 1977

**48** *En route vers l'Inde. 1978.* Photographs with watercolor   Installation view, Venice Biennale, *1978*
Collections of the artist; Dacic, Tübingen; V. Rubiu, Fabio Sargentini, Rome

**49**  *3 Graces, Grasshopper (3 grazie, grillo).* 1980   Ink and watercolor on paper, ca. 6¾″ (ca. 17 cm.) d.   Collection of the artist

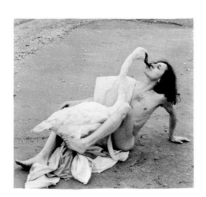

**50**  *Leda and the Swan (Leda e il cigno).* 1975   Life-size photograph by Cesare Bastelli   39⅜ x 59⅛″ (100 x 150 cm.)
Collection Fabio Sargentini, Rome

**51** *Pentagonia.* 1979   Installation view, Galleria Mario Diacono, Bologna, 1979   Collection Achille Maramotti, Reggio Emilia

**52** *Self-Portrait of Gilded Paper Patterns (Autoritratto di carta modelli dorati)*. 1981   Ink with gilt on paper, 118⅛ x 157½" (300 x 400 cm.)
Collection Roberta Maresca, Rome

... "Annunciazione/dichiarazione" come bugia di luce o di Pinocchio

nell'inferno illustrato di DanteGrillo e dell'EcceHomo in tappeto volante

per fugare via dai mostri a 7 Arti di grottesche invisibili

per l'apparizione di Simulacri d'evasione/concentrazione dentro e fuori

(come: Teofania, Adamo/Eva, Le Stagioni e Le Ore, Bacchino, Davide e Golia, San Sebastiano)

Autoritratto in permanenza, epistolario (8) a se stesso, comunicazione d'

Astronaut/Colombo cosmocosmeticomico esplorazione geografica in posa

atemporale, din Don Quijote de la Mancha, Tarzan "En route vers l'Inde"

con fulmini/lampi per Lingam dorato/adorato atto

(8) grafia di messi di figure infinite eredità nell'Eros d'

attimo Eroe (è Pulcinella, Sganappino) di Leda e Cigno" per immanenza di

Dioscuri indimenticAbili come, onnipresenza dell'arte nella vita

lità

ali

alito

(di Santo Natale 81)

**53** *New York.* 1981   Tempera on canvas, seven panels, total 118⅛ x 118⅛″ (300 x 300 cm.)
Courtesy Galleria Lucio Amelio, Naples

**54**  *The Flagellation of Christ.* 1981   China wash on paper, 27⁹⁄₁₆″ (70 cm.) d.   Collection Luciano Pistoi

**55**  *Taprobane.* 1981   Ink and watercolor on paper, 39⅜ x 39⅜″ (100 x 100 cm.)   Collection Ingeborg Lüscher

**56** *3 Graces/Mummies (3 grazie mummie)*. 1980   Ink and watercolor on paper, 39¼″ (155 cm.) d.   Collection of the artist   87

# Giuseppe Penone

Born in Garessio, 1947
Attends Accademia delle Belle Arti, Turin, 1966-68
Artist in residence, Mönchengladbach, Germany, 1979-80
Teaches at Liceo Artistico, Turin, 1970-present
Lives and works in Garessio and Turin

Statement by the artist

*The hand that modeled man has left upon him prints filled by water and air as our movements vary. Indeed, air in filling the prints remakes the maker's skin; the skin of whoever touches the man tends to acquire at that point the shape of the maker's skin. With the negative of his skin impression one can make an infinite number of positives, just as many positives as there will be contacts with the surface in the future. The peaceful state of our body when it is in contact with the air derives from the absence of pressure and weakened resistance which the air offers to our penetration. According to our senses, a rapid penetration in the air provokes in us a sensation of pressure, and the fluid elements tend to become solid. Clay, a solid element which has always been connected to fluids, and with its characteristics of plasticity, reproduces in its movements the behavior of fluids. The whirling, rotating movement produced by the potter tends to facilitate the formation of a vortex in the clay, a typically fluid form, a vortex instantly completed by the air the potter rapidly encloses within it.*

*Above all, the virgin forest must be considered, where the air is enclosed in the leaves in continuous flux under the thrust of the wind's logic, ready to occupy the intervals of quiet, privileged negatives of the form in movement that in repeating itself tends to sculpt itself. Eyelids closed, body numbed, impressed upon an ancient bed; the nape of the neck drowns in the foliage and, with open mouth, the breath sinks into the pile of leaves. Air coursing through the leaves produces the sound, they are food for goats, the lymph that courses produces the leaves, prolongs the earth and permits the pulling away of the bark that, filled with air in place of the wood, becomes an instrument of sound. Elements formed in the air and by the air, in habitual contact with the wind, modeled by the wind, transported by the wind. Retraced by the hand of man, the contours, the whirlpools, the small vortexes, the wrinkling presences of the wind are repeated. To repeat, the wind, the leaves remake themselves.*

Giuseppe Penone's artistic activity cannot be isolated from the activity of nature: united, they form a work of art. The primal forces of nature acting on the environment, combined with the artist's actions form an overwhelming and intensely symbolic, at times symbiotic, relationship. Penone's art is, in essence, an intimate dialogue between himself and nature, a dialogue which has been an integral part of his existence since childhood.

Penone grew up outside of Turin in the rural community of Garessio, a village on the border of the Ligurian Alps and the Valle Padena. From prehistoric times the vicissitudes of nature and weather have directed the course of village life. Traces of human activity dating from the Neolithic and Ice Ages abound in the region: implements of ancient cultures, as well as stones incised with plant and animal motifs by prehistoric artisans have been discovered. Indeed, these archaeological finds have become a source of inspiration for Penone, who feels a spiritual affinity with primitive man in his close relationship with the earth. Conscious of the way natural forces and man have acted upon stone, trees and the environment in general, Penone has sought to use the lessons of his observations in his art and to make an imprint on nature that will be visible to future generations. In 1975 he used paper to make a topographical map which reproduced the fingerprints of a potter found on a shard of an ancient terra-cotta vase. Although he was satisfied with this map, he feels that the use of clay instead of paper would have allowed him to rediscover the shape of the fragment. To illustrate his belief in the possibilities of artistic intervention in the processes of growth and change in nature, he executed a piece for his first one-man show in 1968—he tightly grasped the trunk of a tree with his hand and later placed an iron cast of his hand in the identical posi-

tion on the tree. His message is directly conveyed by the title of the work: *The Tree Will Continue to Grow, Except at that Point.*

Penone shares elements of his artistic ideology with a group of artists working in and around Turin. In the late sixties, these artists, who included Merz, Zorio, Anselmo and Boetti, were searching for a new relationship to nature and to history. The critic Germano Celant named the resulting movement *Arte Povera:* "Like an organism of simple structure, the artist mixes himself with the environment, camouflages himself, he enlarges his threshold of things. [The artist] draws from the substance of a natural event—that of the growth of a plant . . . the movement of a river, of snow, grass and land, the fall of a weight—he identifies with them in order to live the marvelous organization of things."[1] As Penone developed, he drew on Conceptualist and Minimalist aesthetics as well as on *Arte Povera.* He adapted the intellectualism of Conceptualism and the formalism of Minimalism, filtering both through his poetic sensibility. In its final synthesis, his artistic vision is so individual as to defy classification into a single movement.

Penone's uniqueness derives primarily from the affirmation of a perfect syntony which in its extreme suggests the artist's bodily fusion with all of nature. Penone writes:

*In order to produce sculpture the sculptor must lie down, flatten himself on the ground letting his body slide, without lowering himself hastily, gently, little by little and finally, having reached a horizontal position, he must concentrate his attention and his efforts upon his body, which, pressed against the ground, allows him to see and feel against himself the things of the earth; he can then open his arms to fully enjoy the coolness of the ground and attain the necessary degree of peace for the accomplishment of sculpture. . . . When he finally feels light-headed, the coldness of the earth cuts him in half and allows him to see with clarity and accuracy the point which detaches the part of his body which belongs to the void of the sky, and the part that belongs to the fullness of the earth. It is at that moment that sculpture occurs.*[2]

One of Penone's deepest concerns is the discovery of things hidden or internal in nature. He seeks to make visible through his art well-known but invisible natural processes. He strives for a restitution to its original state that which has been altered or forgotten. For example, in 1969 Penone stripped the bark off a section of a tree and made from it a forty-foot-long, ten-inch-square beam (see cat. nos. 57, 58). Then he gouged out of the beam the hidden form of the tree from which it had been made. He shaped the trunk, paying attention both to the grain of the wood and the concentric rings of the cross section which indicated the tree's age. He worked around the knots and burls of the wood to pull back into visibility the limbs and branches that had formed them. In this way, positive volume was uncovered, not built. The tree was not shaped entirely in the round; one side remained uncarved, anchored to the untouched portion of the beam, which served as a base (the piece was exhibited either horizontally or leaning diagonally). By leaving a portion of the beam uncarved, Penone keeps alive a dialogue between that which is man-made and that which is natural. The tree remains suspended between two states: one of completion, one of incompletion. Thus Penone keeps the piece in the realm of sculpture: had he discovered the entire tree while carving, it would have become another tree—and the work of art would no longer have existed.

Penone is executing a tree for exhibition at the Guggenheim, and the unique character of the Museum's space, as designed by Frank Lloyd Wright, dictates certain changes in the conception of this tree. Firstly, Penone will carve the tree completely in the round, exposing all its parts except for the base, a three and half-foot-tall, fifteen-inch-square remnant of the beam from which it was hewn. As in his earlier tree, the artist's challenge will be to find the form of the tree inside the beam, the particular tree whose specific age is indicated by the rings inside the wood. The concentric rings of the Guggenheim's spiral may be interpreted as echoing the concentric rings of Penone's tree. Perhaps on a more general level Wright's sensitivity to natural form appeals to Penone. Because the Museum's spiral is a man-made structure directly inspired by

natural form, Penone's response to the architecture involves a complex interplay between the man-made and the natural. Secondly, the Museum offers the sculptor an opportunity to orient the tree vertically. The vertical is significant for Penone, who feels that sculpture is traditionally vertical rather than horizontal. Moreover, this orientation adds an anthropomorphic dimension to the piece, as man relates more easily to the vertical. The dialogue between art and nature lives on in this new work. It is closer to nature and closer to art than any of his previous work: closer to nature because it looks more like a tree; closer to art because it retains more of the formal properties of traditional sculpture.

Penone's deep concern with purity and beauty of form, whether man-made or natural, recalls Brancusi, an artist he very much admires. The Rumanian sculptor always displayed a profound respect for the inherent properties of wood, sometimes carving his shapes to conform to the way the branches grew from the tree trunk. Penone feels a deep affinity with Brancusi because of the master's belief in the poetic unity and harmonious coexistence of man and nature. His vision was attuned to the realm of essences; he maintained that art should find its inspiration in reality, not in the image.

Penone uses casting as well as carving. This process allows him to explore the relationship between positive and negative volumes, a dialogue that informs most of his work and, indeed, is central to the very concept of sculpture. Casting also permits him to take forms that have been altered by real actions and bring them back to nearly their original states. For example, in 1972 Penone made a plaster cast of his torso. Then he photographed the portion of the torso he had cast. The resulting slide showed areas of his body where hairs, torn away from his skin by the plaster, were missing. When the slide was projected onto the cast, however, Penone seemed to have reached his starting point again, because the sculpture and the slide together constituted an image much like the original torso.

In his *Potatoes* (cat. no. 60), Penone tests how far the forms of nature can be subjected to the pressure of the art form and still remain natural. Penone took impressions of his facial features and made molds from them—the results were negative versions of positive volumes. He buried these molds with germinating potatoes, so that in time they would force the potatoes into physiognomical forms. The process was successful with five potatoes, which Penone subsequently cast in bronze and exhibited among a pile of normal potatoes. Here the artist's concern with alterations of systems of growth and positive and negative volumes finds a new and highly original synthesis.

Terra-cotta is deeply rooted in the long tradition of Italian art: the sculptors of the Renaissance, the ancient Romans and also the Greeks before them favored its use. The recovery of terra-cotta as a viable material has allowed contemporary artists to rediscover rich possibilities and reinvent new and vital forms. Penone sees terra-cotta as a material of the earth whose properties are quite different in its natural as opposed to its fired state. Moreover, the fluidity of the medium when mixed with water and its ability to capture ephemeral forms which do not lose their freshness when the clay hardens appeal to Penone's poetic sensibility. In his terra-cotta sculptures Penone reopens the question of how to make visible what is well-known but invisible (or barely visible) in nature, in this case, the process of breathing. Penone's terra-cottas are called *Breath (Soffio)* and take two forms—vases and leaves (cat. nos. 61-63, 68). Indeed, the two forms are combined in one image in the later works. The artist seeks to rediscover in his *Soffi* the process of breathing, the breath being both an extension of man and of nature, in the form of wind. When a vase maker constructs a vase on the potter's wheel, his breath remains inside the work; his breath, in fact, gives the work its life. Penone relates this phenomenon to Egyptian mythology, where the creator of man was a vase maker: "Prometheus, son of Japhet and Clymene, modeled the men with mud and water while Athena blew into them the breath of life."[3] In fact, the word "sculptor" in Egyptian translates as one who gives life.

For each leaf piece Penone amasses a large pile of leaves in the forest and then blows into the pile

to obtain what he calls "the negative form" of blowing. He subsequently translates this into a terracotta equivalent—a large vase shape (cat. no. 62). The leaves displaced by blowing are suggested by the delicately modeled clumps of clay which define the undulating perimeter of the hollowed out negative form. Penone leaned against the clay, leaving the imprint of his body visible on the vase, so that here, as in all of Penone's work, there is an intense human dimension. When the viewer presses against the sculpture, his body completes the work and he can blow into the palette-shaped mouthpiece. If one were to blow into a pile of real leaves, they would move, fill out the negative form and return to their original positions. But this cannot happen in the *Soffi.* Penone thus creates a tension between the original, concrete form and the abstract, implied possibilities of its altered version.

For Penone, the reality of art is and remains a matter of association. His work illustrates various tangents of that reality, with an expressiveness which depends neither on drama nor pathos, but on beauty and poetry. His sculpture is quiet, but by no means reticent. Every action Penone imposes upon nature—whether external or his own body—opens up a dialogue between the natural and the man-made, the internal and the external, the fluid and the concrete, the vertical and the horizontal or between negative and positive volume. Penone does not seek to interpret nature and its often mystical forces; he attempts only to portray the possibilities and limitations inherent in the encounter between the artist and nature. Such encounters have already produced, and will continue to produce, statements of poetic resonance and timeless beauty.

## Footnotes

1. Celant, *Arte Povera,* 1969, p. 225
2. Kunstmuseum Luzern, 1977, p. 79
3. Ibid., p. 78

## Selected Group Exhibitions

Städtische Kunsthalle, Düsseldorf, *Prospect 69: Internationale Vorschau auf die Kunst in den Galerien der Avantgarde,* September–October 1969

Städtisches Museum Leverkusen, Schloss Morsbroich, *Konzeption—conception: Dokumentation einer heutigen Kunstrichtung,* October-November 1969

Galleria Sperone, Turin, *Disegni e progetti,* 1969

Museo Civico, Bologna, *III Biennale internazionale della giovane pittura: Gennaio 70. Comportamenti. Progetti Mediazioni,* January 1970. Catalogue with texts by Renato Barilli, Maurizio Calvesi and Tommaso Trini

Tokyo Metropolitan Art Gallery, *Biennial '70,* May 1970. Traveled to Kyoto Municipal Art Museum; Aichi Prefectural Art Gallery, Nagoya; Fukuoka Prefectural Culture House

Kunstmuseum Luzern, *Processi di pensiero visualizzati: Junge italienische avantgarde,* May–July 1970. Catalogue with texts by Jean-Christophe Ammann and Germano Celant

Galleria Civica d'Arte Moderna, Turin, *Conceptual Art, Arte Povera, Land Art,* June–July 1970. Catalogue with texts by Germano Celant, Lucy Lippard and A. Passoni

The Museum of Modern Art, New York, *Information,* July–September 1970

Sala di Cultura, Modena, *Arte e critica '70,* 1970

Kunstverein München, Munich, *Arte Povera: 13 italienische Künstler,* May–June 1971. Catalogue with text by Germano Celant

Parc Floral de Paris, Bois de Vincennes, *Septième Biennale de Paris: Manifestation biennale et internationale des jeunes artistes,* September–November 1971. Catalogue with text by Achille Bonito Oliva

Addison Gallery of American Art, Phillips Academy, Andover, Massachusetts, *Formulation,* 1971

Museum Fridericianum, Kassel, Germany, *Documenta V,* June–October 1972. Catalogue

Galerie MTL, Brussels, *Huit Italiens / Acht Italianen,* January-February 1973. Traveled to Art and Project, Amsterdam

Palazzo delle Esposizioni, Rome, *X Quadriennale nazionale d'arte: La ricerca estetica dal 1960 al 1970,* May–June 1973

Kunstverein Hannover, *Kunst aus Fotografie,* May–July 1973. Traveled to Städtische Kunstsammlungen Ludwigshafen. Catalogue with text by Helmut R. Leppien

The Arts Council of Northern Ireland Gallery, Belfast, *An Exhibition of New Italian Art,* November

1973. Traveled to The David Hendriks Gallery, Dublin

Galleria Civica d'Arte Moderna, Turin, *Combattimento per un'immagine,* 1973

Städtisches Museum Leverkusen, *Die verlorene Identität: Zur Gegenwart des Romantischen,* May–June 1974. Catalogue with text by Rolf Wedewer

Galerie Paul Maenz, Cologne, *13 "Projekt '74" Artists,* July 1974

Kunsthalle Köln, Cologne, *Projekt '74, Kunst bleibt Kunst: Aspekte internationaler Kunst am Anfang der 70er Jahre,* July–September 1974. Catalogue with texts by M. Grüterich, W. Herzongenrath, D. Ronte, M. Schneckenburger, A. Schug and E. Weiss

Galerie Magers, Bonn, *28 Selbstporträte,* 1974. Catalogue with text by Werner Lippert

São Paulo, *XII Bienal de São Paulo,* October–December 1975

Galleria Sperone, Rome 1975

Centre des Arts Plastiques Contemporains, Bordeaux, *Identité / Identifications,* April–June 1976

Galerie Paul Maenz, Cologne, *Pläne-Zeichnungen-Diagramme,* September 1976

Städtische Kunsthalle, Düsseldorf, *Prospectretrospect, Europa 1946-1976,* October 1976

The Art Gallery of New South Wales, Sydney, *Recent International Forms in Art: The 1976 Biennial of Sydney,* November–December 1976

Kunsthaus Zürich, *Malerei und Photographie im Dialog von 1840 bis Heute,* May–July 1977

Galleria Civica d'Arte Moderna, Turin, *Arte in Italia 1960-1977,* May–September 1977. Catalogue with texts by Francesca Alinovi, Renato Barilli, Antonio Del Guercio and Filiberto Menna

Venice, *La Biennale di Venezia: Dalla natura all'arte, dall'arte alla natura,* June 1978. Catalogue with texts by Jean-Christophe Ammann, Achille Bonito Oliva, Antonio Del Guercio and Filiberto Menna

Hamburger Kunsthalle, Hamburg, *Das Bild des Künstlers: Selbstdarstellungen,* June–August 1978. Catalogue with text by Siegmar Holsten

Stedelijk Museum, Amsterdam, *Door beeldhouwers gemaakt: Made by sculptors,* September–November 1978

Städtische Kunsthalle, Düsseldorf, *Museum des Geldes: Ueber die seltsame Natur des Geldes in*

*Kunst, Wissenschaft und Leben I/II,* 1978. Traveled in 1978-79 to Kunstverein für die Rheinlande und Westfalen; Stedelijk van Abbemuseum, Eindhoven; Musée National d'Art Moderne, Centre d'Art et de Culture Georges Pompidou, Paris

Castello Colonna, Genazzano, *Le Stanze,* November 1979. Catalogue with text by Achille Bonito Oliva

Venice, *La Biennale di Venezia: Aperto '80, Art in the Seventies,* June 1980. Catalogue with texts by Achille Bonito Oliva, Michael Compton, Martin Kunz and Harald Szeemann

Museen der Stadt, Cologne, *Westkunst,* May–August 1981. Catalogue with texts by Marcel Baumgartner, Laszlo Glozer and Kasper Koenig

Musée National d'Art Moderne, Centre d'Art et de Culture Georges Pompidou, Paris, *Identité italienne: l'art en Italie depuis 1959,* June–September 1981. Catalogue with text by Germano Celant

**Selected One-Man Exhibitions**

Deposito d'arte presente, Turin, 1968

Galleria Sperone, Turin, December 1969; *Il pelo, come l'unghia e la pelle, occupa spazio,* October 1973; *1216 peli,* March 1975

Aktionsraum I, Munich, February 1970

Galleria Toselli, Milan, 1970; 1973

Incontri Internazionali d'Arte, Rome, *Rovesciare i propri occhi,* November 1971

Galerie Paul Maenz, Cologne, July 1972; May–June 1973; February–March 1975; *un anno di arte italiana,* January–February 1978, catalogue with text by Germano Celant; 1980

Galleria Multipli, Turin, February 1973; *6 opere,* March 1975

Galleria Sperone–Fischer, Rome, December 1973

Galerie Klaus Lüpke, Frankfurt, 1973

Galerie 't Venster, Rotterdam, *Piede / 1972,* November–December 1974

Galleria Schema, Florence, 1974

Samangallery, Genoa, April 1975

Sperone Gallery, New York, 1975

Nuovi Strumenti, Brescia, 1976

Studio De Ambrogi, Milan, 1976

Kunstmuseum Luzern, May 1977. Catalogue with texts by Jean-Christophe Ammann, Ugo Castagnotto and Giuseppe Penone

Staatliche Kunsthalle Baden-Baden, *Giuseppe*

*Penone,* January 1978. Catalogue with texts by Jean-Christophe Ammann, Renato Barilli, Giuseppe Penone and Hans Albert Peters

Galerie Rudolf Zwirner, Cologne, March 1978

Museum Folkwang, Essen, September–October 1978. Catalogue with texts by Germano Celant, Z. Felix and Giuseppe Penone

Galleria De Crescenzo, Rome, October 1978

Galleria Salvatore Ala, Milan, November 1978

Galerie Durand-Dessert, Paris, January–February 1979

Studio G7, Bologna, 1979

Halle für internationale neue Kunst, Zürich, *Giuseppe Penone: Zucche e nero assoluto d'Africa,* November 1979–January 1980

Stedelijk Museum, Amsterdam, *Giuseppe Penone,* February 1980. Catalogue with texts by Germano Celant and Giuseppe Penone

Kabinett für Aktuelle Kunst, Bremerhaven, April 1980

Galleria Christian Stein, Turin, May 1980

Salvatore Ala, New York, March 1981

Konrad Fischer, Düsseldorf, September–October 1981

## Selected Bibliography
BY THE ARTIST

*Svolgere la propria pelle,* Turin, 1971

With Jean-Christophe Ammann, *Rovesciare gli occhi,* Turin, 1977

ON THE ARTIST

*Newspapers and Periodicals*

Henry Martin, "From Milan and Turin: Gian Enzo Sperone Gallery," *Art International,* vol. 15, December 1971, pp. 75-76

Tommaso Trini, "The Sixties in Italy," *Studio International,* vol. 184, November 1972, pp. 165-170

Tommaso Trini, "Anselmo, Penone, Zorio e le nuove fonti d'energia per il deserto dell'arte," *Data,* no. 9, Autumn 1973, pp. 62-67

Werner Lippert, "Das Selbstporträt als Bildtypus," *Kunstforum International,* no. 14, March 1975, pp. 99-124

Werner Kruger, "Deutschland," *Art International,* vol. 19, April 20, 1975, p. 8

Rolf-Gunter Dienst, "Giuseppe Penone: Staatliche Kunsthalle, Baden-Baden," *Kunstwerk,* vol. 31, June 1978, pp. 83-84

"Giuseppe Penone: Folkwangmuseum, Essen," *Heute Kunst,* no. 24, January 1979, p. 8

"Giuseppe Penone: Giuliana De Crescenzo/Roma," *Flash Art,* no. 86-87, January–February 1979, p. 13

"Giuseppe Penone: Studio Ala/Milano," *Flash Art,* no. 86-87, January–February 1979, p. 9

Corinna Ferrari, "Stanze del Castello," *Domus,* no. 604, March 1980, p. 55

Laura Cherubini, "The Rooms: Castello Colonna/Genazzano," *Flash Art,* no. 96-97, March–April, 1980, pp. 42-43

Giuseppe Risso, "Giuseppe Penone: Each Blow of the Hoe," *Domus,* no. 609, September 1980, p. 53

Henry Martin, "The Italian Scene, Dynamic and Highly Charged," *Art News,* vol. 80, March 1981, pp. 70-77

Lisa Liebmann, "Giuseppe Penone at Salvatore Ala," *Art in America,* no. 10, December 1981, pp. 147-148

*Books*

Germano Celant, *Arte Povera,* Milan, 1969

Lea Vergine, *Il corpo come linguaggio,* Milan, 1974

Achille Bonito Oliva, *Europa/America,* Milan, 1976, p. 235

Paolo Mussat Sartor, *Paolo Mussat Sartor/Fotografo 1968-1978/Arte e Artisti in Italia,* Turin, 1979, pp. 181-199

**57**
*Repeat the Forest (Ripetere il bosco).* 1969-80
Wood
Installation view, Stedelijk Museum, Amsterdam,
1980

**58**
*8 Meter Tree (Albero di 8 metri).* 1969
Wood, 26′ x 7½ x 4″ (8 m. x 19 x 10 cm.)
Installation view, Salvatore Ala Gallery, New York,
1981

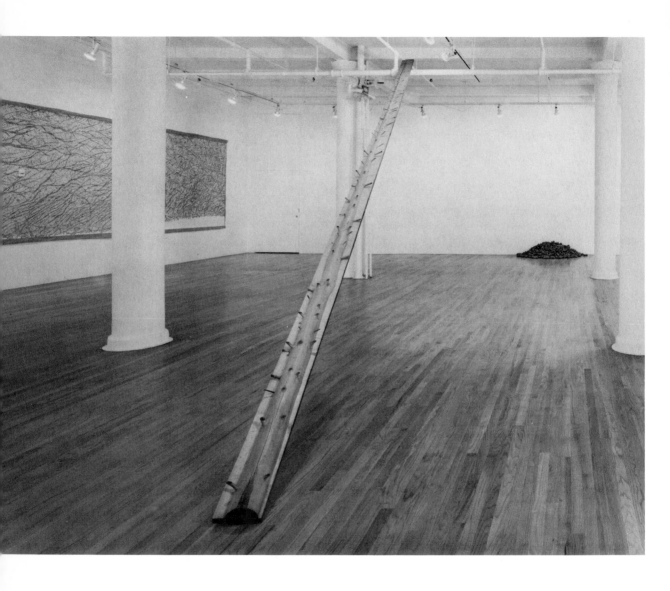

**59**

*Eyelid (Palpebra).* 1974; *8 Meter Tree (Albero di 8 metri).* 1969; *Potatoes (Patate).* 1977
Installation view, Salvatore Ala Gallery, New York, 1981

**60**

*Potatoes (Patate).* 1977
Cast bronze and potatoes
Installation view, Salvatore Ala Gallery, New York, 1981

**60**
Detail

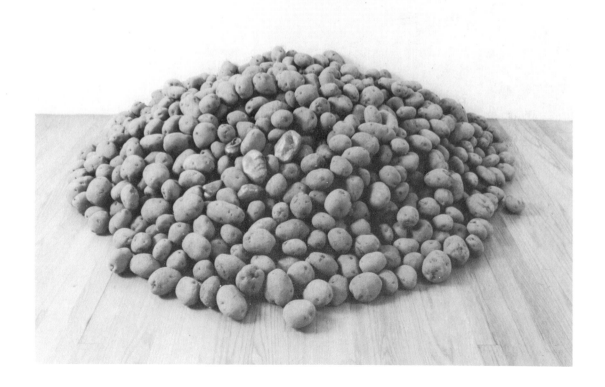

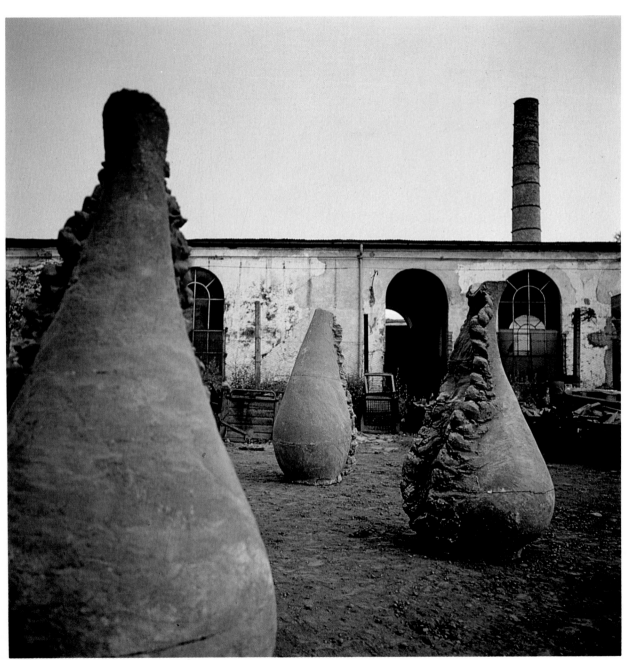

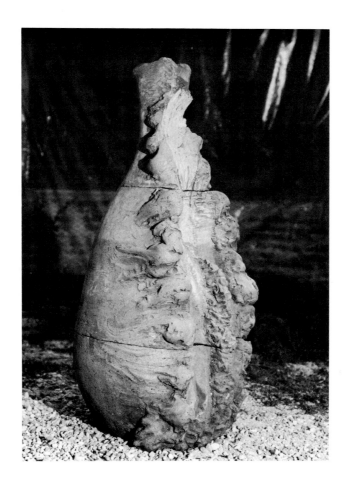

**61**

*Breaths No. 4, 5, 6 (Soffi no. 4, 5, 6).* 1978
Terra-cotta
Installation view, farmhouse courtyard, Castella-
monte, province of Turin

**62**

*Breath No. 1 (Soffio no. 1).* 1978
Terra-cotta, 57¾ x 28¼ x 25½ " (148 x 72 x 65 cm.)
Collection Stedelijk Museum, Amsterdam

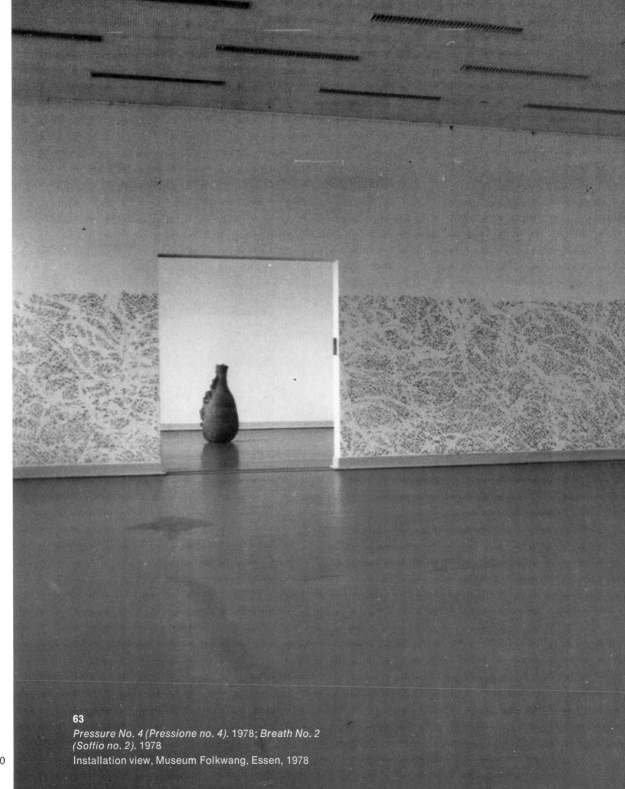

**63**
*Pressure No. 4 (Pressione no. 4).* 1978; *Breath No. 2
(Soffio no. 2).* 1978
Installation view, Museum Folkwang, Essen, 1978

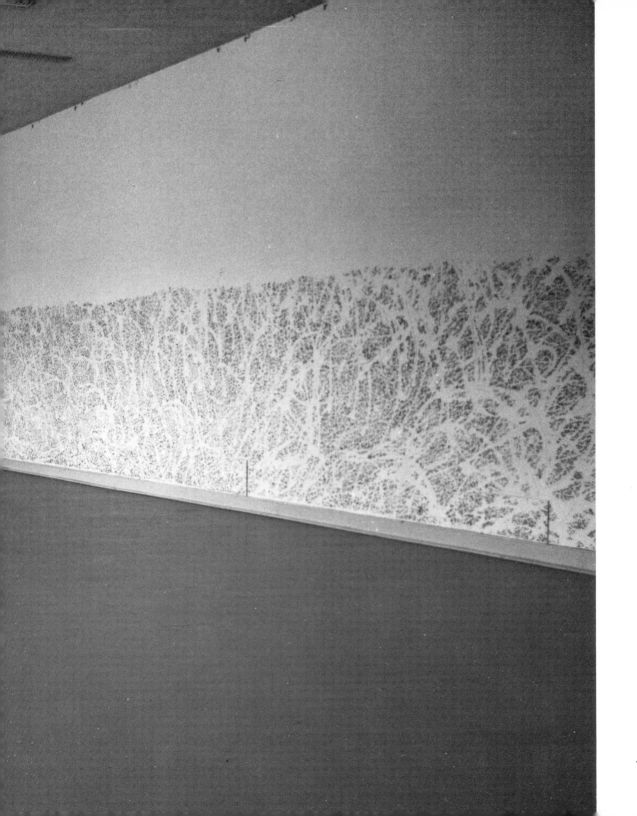

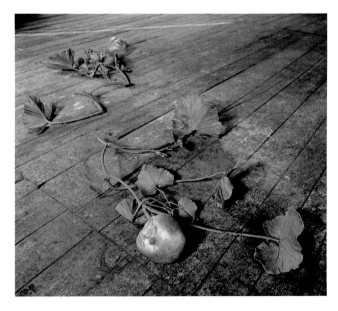

**64**
*Squash (Zucca).* 1978
Photograph of altered vegetable before casting

**65**
*Squash (Zucche).* 1979
Detail, *Squash and Absolute Black from Africa*
Bronze, 51 x 31½ x 15¾ ″; 43¼ x 31½ x 15¾ ″
(130 x 80 x 40 cm.; 110 x 80 x 40 cm.)
Collection Crex, Zürich

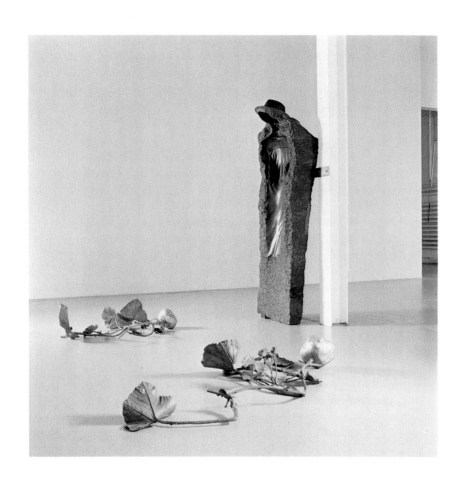

**66**

*Squash and Absolute Black from Africa (Zucche e nero assoluto d'Africa).* 1978-79

Installation view, Halle fur internationale neue Kunst, Zürich, 1979-80

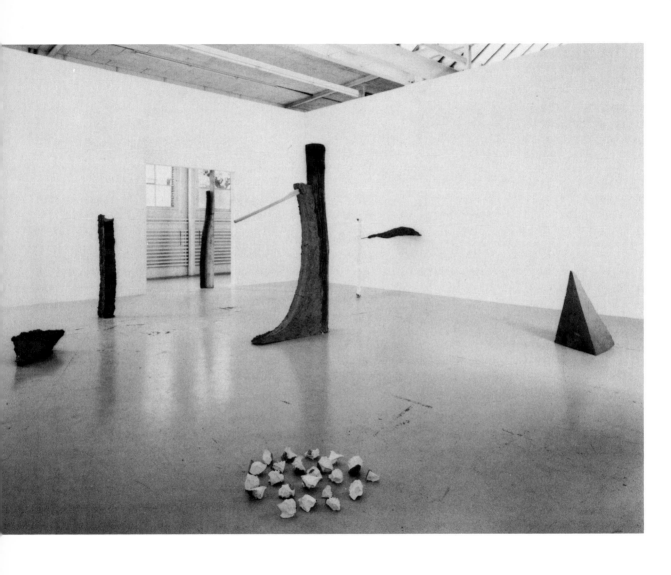

**67**

Clockwise: *Vase (Vaso); Venus Horizontal (Venus orizzontale); Venus Vertical (Venus verticale); Tree (Albero); Hoe (Zappa); Breath of Leaves and Tree of Water (Soffio di foglie e albero d'acqua); Hoe II (Zappa II).* All 1979-80

Installation view, Halle fur internationale neue Kunst, Zürich, 1979-80

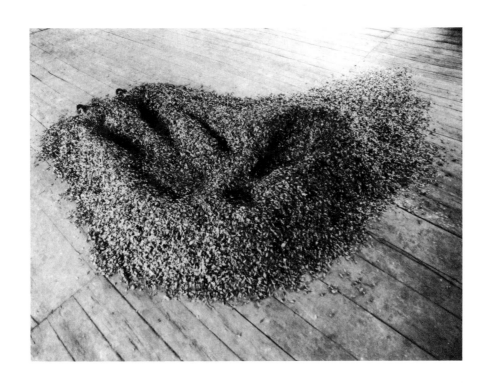

**68**
*Breath of Leaves (Soffio di foglie).* 1979
Cast bronze and leaves
Installation view, artist's studio, Turin

# Vettor Pisani

Statement by the artist

### Il teatro a coda

*R.C. Theatrum, Teatro di artisti e di animali, si può giustamente definire un teatro a coda o con la coda perché in questo teatro Tutto e tutti hanno la coda (teatro democratico, una scuola d'arte aperta a tutti).*

*La coda ce l'ha naturalmente il coniglio nel Piccolo Teatro. Ce l'ha la ballerina di nome Giò, in arte Rose Baby Casta, che indossa un abito da coniglietta e che esegue nel Grande Teatro un vertiginoso strip-tease. Ce l'ha il musicista che somiglia all'Edipo di Khnopff e che accompagna la ballerina con musiche di Satie. In verità lui esagera; di code ne ha due: indossa il frac. Ce l'ha lo strumento musicale che il musicista suona: un pianoforte a coda di colore nero. Ce l'ha il teatro tutto. Infatti si può considerare il fiume sul quale il teatro è costruito come la coda della sua architettura a forma di Croce.*

*Infine non vorrei dimenticare la coda dell'autore del teatro. Personalmente considero la mia fantasia (che non finisce mai) come la coda della mia immagiazione, dell'Io.*

*Roma, estate 1981*

Architect, sculptor, painter and playwright (author of theatre).

Son of a marine officer, descendant of a Venetian family established for many years on the island of Ischia, and a stripper. Born in Bari in 1935 on one of the numerous trips that his mother made while following his father from port to port.

Entrusted to his father's family for his education, he lived on Ischia until 1945.

Pisani moved to Naples where he attended a Jesuit school and subsequently began the study of architecture.

At 19, Pisani left his family definitively to become a disciple of an R.C. Master/Instructor.

In 1970, after many years of study in complete silence, he exhibited for the first time in Rome, winning the Premio Nazionale Italiano della Critica d'Arte (Italian National Art Critics Award).

He has founded in Rome, a city he rarely leaves, an R.C. theatre and school of art.

*The artist has requested that no further documentation be included.*

"The labyrinth from which Theseus escaped by means of the clew of Ariadne was built by Daedalus, a most skilful artificer. It was an edifice with numberless winding passages and turnings opening into one another, and seems to have neither beginning nor end, like the River Meander, which returns on itself, and flows now onward, now backward, in its course to the sea."[1] Vettor Pisani, a contemporary Daedalus, architect and artificer in his own right, expands upon the mythological definition of the labyrinth in his art: it is manifested physically as well as in a more abstract dimension where a number of recurrent symbols intertwine to form a complex theatre of images and ideas. Among the themes he cultivates to this end are alchemy, the Oedipus legend, androgeny, the occult and Rosicrucianism. Pisani also pays homage to past history and its artists, most recently Duchamp, Beuys and Klein. He treats their art as material for making his own art, and subjects it to a critical and systematic analysis. For Pisani, art is about criticism; criticism is not only an attribute of art, it is art itself. Inseparable from the symbolic and critical elements of his work is an inherent concern with pure aesthetics, with color, scale and light, with classical harmony and formal clarity.

Like the labyrinth and Oedipus legends he so reveres, Pisani's art holds many secrets, secrets not easily unmasked. Nor is it Pisani's intention that the viewer penetrate the many-leveled symbolism, the often obscure mysticism he cultivates. Symbolism nourishes his art, which speaks to the sentiments expressed by the Symbolist poet, Mallarmé: "To name an object is to suppress three-quarters of the pleasure in a poem, which is made to be discovered little by little: to suggest, that is the dream. It is the perfect use of this mystery which is the symbol: to evoke a thing little by little, in order to reveal its soul, or conversely, to choose an object and through gradual deciphering release its spirit."[2]

Pisani's oeuvre can be divided into two distinct phases: the Performance Art of the early seventies and the more object-oriented work of the latter half of the decade to the present. In performance Pisani found an outlet for his critical analysis of the work

of other artists through which he is able to define himself as an artist. Performance Art in Italy has been based predominantly in Rome, and its major protagonists have included Pierpaolo Calzolari, Gino de Domincis, Jannis Kounellis and Pisani. American Performance Art was apolitical and centered around the commonplace; the Happenings of the sixties, related to the Pop Art movement, integrated art and dance and involved everyday events, objects and environments and, often, the participation of the audience. European Performance Art reveals a distinctly different approach. Despite the charged social and political context of many of the performances, their content and vocabulary are highly sophisticated and arcane, drawn from cultural history and centered on masks, symbols, rituals and mythology.

Pisani finds historical precedents for the performance aspects of his art, as well as for its conceptual complexity, in the work of the two artists he most admires, Duchamp and Beuys. Both offer to him the concept of living, or life itself, as the creative field: Duchamp in his continual testing of the boundaries between art and life, Beuys in his expansion of the creative realm to include what he calls "actions." Duchamp's art assumes the contradictoriness of life itself; his perpetual investigation of the meaning of art ("Can one make works which are not works of 'art'?") was embodied in his Readymades, common manufactured objects elevated to the realm of art. These Readymades were for artists of Pisani's generation not only an antidote to the painterly aesthetic of the fifties, but an example of a kind of ideal freedom with which to develop their expression. Duchamp's elegance, detachment and irony are at opposite extremes to Beuys's approach to his commonplace subject matter: his brutal aesthetics as well as his serious involvement with its social implications, its political and revolutionary possibilities. Nevertheless, Duchamp and Beuys have been equally pertinent for Pisani, who has synthesized and distilled their ideas to endow his own art with a richness of symbol, expression and form.

Pisani's first one-man show in 1970 at the Galleria La Salita in Rome was the culmination of five years of a critical and systematic analysis of Duchamp's work. Entitled *Studies of Marcel Duchamp 1965-70: Masculine, Feminine, and Androgyne. Incest and Cannibalism in Marcel Duchamp*, the exhibition consisted of a text and a black plaque with the names of Marcel and his sister Suzanne incised in gold, a classical bust of Suzanne carved out of chocolate, which hung from a heavy apparatus attached to the ceiling, and a plastic bag of ground meat left to putrify. A theatrical performance was held in conjunction with the visual display. The many-leveled symbolism of alchemy, which involves the themes of the androgyne and brother-sister incest, two subjects of central concern to Duchamp, play an important part here, as throughout Pisani's work. Alchemy, an ancient art of obscure origins, was concerned with the transformation of base metals into gold. In addition, alchemy has rich symbolic meaning in a psychological context. As Arturo Schwartz has written in a study on Duchamp:

*The material liberation of philosophic gold from vulgar metal is a metaphor for the psychological processes concerned with the liberation of man from life's basic contradictions. . . . Only by acquiring this "golden understanding" will the adept succeed in achieving the higher consciousness that is the first stage toward the reconstitution, at a higher level, of the unity of his divided self. Jung terms this psychological process "individuation." . . . Individuation, in the alchemical sense, entails abolishing the conflicting male-female duality within the integrated personality of the reconstituted Gnostic Anthropos, i.e. the original androgyne. . . . Here brother-sister incest is envisaged as a means of resolving the contradiction of the male-female duality in the reconstituted androgynous unity of the primordial being, endowed with eternal youth and immortality.[3]*

The Duchampian themes of brother-sister love (embodied in references to the relationship between the artist and his sister Suzanne) and the sexual ambiguity of persona (for example, the ironic female disguise of his alter ego Rrose Sélavy) are sources for numerous variations by Pisani on the subject of androgeny, such as his 1971 tableau *Human Flesh and Gold*. Here a gold breastplate with a female breast is strapped to the right side of a nude male, while a woman wears a tight black band that com-

pletely covers and flattens her right breast. Through the juxtaposition of male and female, an androgenous being is suggested. Pisani has further explored the alchemical aura of Duchamp's work in rituals he has performed with his sister Mimma's body.

The alchemical writings of the Middle Ages are couched in symbolic and cryptic language which confers upon them an atmosphere of secrecy and mysticism and the status of a hermetic science. In fact, the alchemists often called themselves the "sons of Hermes," to whom they ascribed the origins of their "Hermetic Art." Pisani has incorporated many of the precepts of alchemical doctrine into his works. For example, alchemical thought attached great importance to color (in particular black, white, yellow and red) and color changes, concepts which play significant and expressive roles in Pisani's oeuvre. Alchemists sought to discover an elixir known as the Philosopher's Stone which held the secret of immortality. Pisani, too, is fascinated by the theme of eternal life, which reverberates throughout his work. In addition, alchemical doctrine held that the cosmos originated in and found its interpretation in numbers, and that four is a magic number because there are four primary elements. Pisani sees Duchamp, Klein and Beuys as part of a hermetic and esoteric culture to which he dedicates his work and he believes that together with these artists he forms a system based on the magical number four.

In 1973 Duchamp and Beuys meet, albeit in an antithetical sense, in a performance by Pisani, *All the Words from the Silence of Duchamp to the Noise of Beuys*, so titled in reference to Beuys's 1964 action, *The Silence of Duchamp is Overrated*, which was a criticism of Duchamp's anti-art concepts. Like many of Pisani's works, this performance occupies four spaces. In the first room a nude woman seated at a table bangs on plates to scare away the guinea pigs that eat at her feet. In the second the artist is painting flags next to a dead dove. A photograph of a nude man adorns one wall of the third room; across from it is a shield emblazoned with the words, "The hero is nobody." And finally, in the fourth room are two photographs, one of the *Gio-conda*, the other of Duchamp looking at the *Gioconda*. The taped laughter of Beuys echoes throughout all four rooms.

Beuys's work more literally becomes the subject of Pisani's critical method in *The Rabbit Does Not Love Joseph Beuys*, first performed in Rome in 1975 and subsequently at the 1976 Venice Biennale (see cat. nos. 77, 78). The piece features the German actress Karla Koenig dressed in black, reciting the sentence, "The rabbit does not love Joseph Beuys" in German, modulating her voice from a shout to a whisper, from a murmur to an exalted tone. In one performance she stands under a sign with gold-leaf letters declaring "*Il coniglio non ama Joseph Beuys*," holding two tiny Jesus figures in her hands. In another, an illuminated, red-painted cross lies on the ground in front of her. The rabbit is the symbol of nature in these works and Beuys is the hero emblem, the artist-demiurge who through art transforms nature into culture. Thus Pisani sets up the equations rabbit = nature; Beuys = man and says "nature does not love man."

Pisani's critical method involves the appropriation of elements from other artists and from art history, their analysis and reinvention. He examines the old meanings of these elements and creates variations on them; and he discovers new meanings as he integrates old symbols into new contexts. Thus, in *The Rabbit Does Not Love Joseph Beuys*, which refers specifically to Beuys's 1966 action *Eurasia*, Pisani takes from Beuys the half-cross, the swastika, the dead hare, the concepts of the orient and occident; he integrates these elements into a new work which not only comments upon Beuys's piece but also has a new and independent significance. Pisani explores the concepts of orient and occident in another work, a drawing of a planisphere. Bruno Corà explains that this drawing "shows how the neologism EURASIA came into being as the lexical symbiosis of EUROPE and ASIA, if with the cross reconstructed to scale, the letters O P E (of Europe) are covered as, albeit differently, in the Duchampian practices of homophony adopted by Beuys himself."[4] A similar iconological analysis can be made of the pencil drawing on the theme of *The Rabbit*

*Does Not Love Joseph Beuys* entitled *The Artist Who Loves Nature* (cat. no. 79). This drawing is based in part on an anonymous fourteenth-century Italian ink drawing of a man with similarly fantastic anatomy, a reference which enlarges and complicates the labyrinth of the work's associations. Here, as in all of Pisani's art, our analysis can only yield an interpretation of meaning, a suggestion of how we may understand its significance; indeed, our analysis yields further enigmas.

In the late seventies Pisani began to displace his performances with a series of installations entitled *R.C. Theatrum*. Themes of his earlier artistic activity are reintroduced here, along with several new motifs, most notably the exploration of the secret occult doctrine of Rosicrucianism. Rosicrucian (R.C.) lore is concerned with the precepts of alchemy and hermeticism, antique myths, mysticism, exoticism, unknown lands and the Cabalistic distillation of secrets hidden in numbers, words and things. At the age of nineteen Pisani became a disciple of an R.C. master, and the symbols of this esoteric society, in particular the rose and the cross, the swastika and the pyramid, have played a part in his work since its inception. *R.C. Theatrum* becomes for Pisani a symbolic arena, a labyrinth, in which to resolve the conflicts and dualities his art embodies: male and female, order and chaos, darkness and light, nature and culture, the physical and the spiritual.

More specifically, *R.C. Theatrum* is the artist's own ironic definition of a theatre of initiation, which takes as its point of departure the ancient Eleusian mystery cult. The Greek cult, known also as the Mysteries of Demeter, involved a secret religious ritual which revealed to its initiates the mysteries of the goddess. The initiation was comprised of three stages: a preliminary initiation into the Lesser Mysteries, where the body was purified, the initiation proper into the Greater Mysteries and, finally, the *epopteia,* available to those who aspired to a higher degree of understanding.

In "Il Teatro a Coda" (see the artist's statement, p. 106), Pisani presents a verbal equivalent for these rituals. The text is a code whose secret is revealed to the reader who can transcend the narrative and understand its metaphorical meaning; because of its special nature, the text cannot be translated without losing this meaning. According to Pisani, the *coda* (literally "tail") symbolizes ignorance, which the reader/initiate must overcome. Each character in his theatre—the rabbit, the ballerina, the musician who resembles Khnopff's Oedipus and accompanies the dancer with the music of Satie (a fellow Rosicrucian), the black grand piano, the theatre itself and the author of the theatre (Pisani)—has a tail. The theatre is divided into two sections, paralleling the stages of initiation in ancient Greece: the Lesser Theatre, represented by a male rabbit, and the Greater Theatre, in which the dancer Rose Baby Casta wears a rabbit costume and performs a dizzying striptease. Throughout the text Pisani engages in verbal punning in the manner of Duchamp. For example, the stripper's given name is Gio, an ironic counterpart to her stage name Casta, which means virgin, and together the names spell Giocasta, the mother and wife of Oedipus, one of Pisani's principle protagonists. The theme of Rosicrucianism is buried within the text, embodied in the words "Rose" and "Croce," which are separated from each other by several sentences. Furthermore, the word "tail" and Pisani's subtitle for *R.C. Theatrum,* "theatre of artists and animals," constitutes a veiled reference to the Sphinx, whose riddle only Oedipus is able to solve. The rites of Eleusias symbolized the annual cycle of death and rebirth in nature, as well as the immortality of the soul. Here Pisani's symbolism comes full circle, for the theme of immortality calls to mind not only the alchemists' quest for the Philosopher's Stone, but also the riddle of the Sphinx. The elliptical nature of Pisani's logic, and indeed of his entire oeuvre, is thus encapsulated in "Il Teatro a Coda."

An installation of *R.C. Theatrum* at Galleria Mario Pieroni in Rome in 1980 took place in four rooms. Its central characters were two builder saints of the Roman basilica of the Quattro Coronati. The saints hold up emblems of a T-square and a compass and thereby serve as symbols of the dialectic between the straight line and the curve, between the logical order of reason and the more circular order of the

soul. Here, as throughout Pisani's work, color is used both for its aesthetic qualities and its symbolic associations: the figures are red and green, complimentary colors which refer to the complimentary symbolic roles of the saints and also, significantly, call to mind the Italian flag. The saints introduce an area where this duality is sustained, a theatre in the shape of a cruciform structure, a reference to Beuys's divided cross in *Eurasia*. The two arms of the cross are turned inward, to form the sign of the labyrinth, a place of mystery and profundity, a microcosm of life. In this room are Oedipus and the Sphinx as portrayed in the painting *The Caresses* by the nineteenth-century Belgian Symbolist and Rosicrucian Fernand Khnopff. Pisani superimposes a photograph of Khnopff's figures on a photograph of a pyramid at the entrance to the Protestant cemetery in Rome (cat. no. 81). The themes of incest (here mother and son as well as sister and brother) and androgeny are reintroduced: the face of the Sphinx is that of Khnopff's sister and favorite model Marguerite, whose beauty obsessed him; the Sphinx embraces Oedipus and their heads touch, suggesting fusion and the impossible androgeny that would derive from the union of their bodies.

The "third moment" in the Pieroni installation is a molded plastic maquette of Ischia, the island of Pisani's birth (see cat. no. 76). It is covered with a brilliant blue powder, the deeply resonant and electric cobalt named International Klein Blue by Yves Klein. There are many striking parallels between Klein and Pisani. Klein's art, like Pisani's, is subtle, mysterious, ambiguous and hermetic, concerned with a complex and powerful constellation of ideas. As a young man, Klein was involved with Rosicrucianism. A powerful sense of ritual and mystery infuse Klein's painting, sculpture and performances. He moved from the use of monochrome blue to the alchemical colors red and gold. Pisani's color, like Klein's, is highly symbolic. In appropriating International Klein Blue, Pisani appropriates as well its symbolic meaning: it represents infinite space and suggests the sea and the sky, the most abstract elements of nature. The intense blue and the self-contained quality of the island, the bright light which

illuminates the maquette, as well as the aerial perspective from which it is viewed, produce a powerful optical and sensory experience. This island is a reinterpretation of the Swiss Romantic painter Arnold Boecklin's *The Island of the Dead*. In fact, the model of Ischia was exhibited with a collage of Khnopff's Oedipus and Sphinx and Boecklin's painting at Galleria La Salita in 1980.

When the maquette was shown at the Salvatore Ala Gallery in New York in 1980, a new caption provided an additional level of meaning: "Light brings from the blue of the sea to the island of my infancy before your eyes." Thus Pisani recaptures emotional experience from his childhood in this work. Yet its meaning extends beyond autobiography, as Mimma Pisani explains, ". . . the cosmic, blue dimension, as a vision from on high, combines with the idea of illumination—metaphysical light because of the signs emerging from the imaginary world of the artist. In the gallery the island landscape of childhood vibrates light like an apparition within the light of the glass windows and the blue by which it is permeated. The order-forming hero, Oedipus and the mask of masks, the Sphinx, are the privileged characters of this theatre."

Whereas the island in the Pieroni installation represents the room of infancy and light, the fourth and final moment is a nocturnal room, in which are gathered symbols of sleep and death. Significantly, solar and nocturnal imagery are extremely pertinent to alchemical doctrine, as well as to the myth of the labyrinth. Here cypresses, symbols of mourning and immortality, rise from a sofa covered with a sepulchral white fabric. The incongruity of this juxtaposition of elements, which perhaps recalls Duchamp's altered Readymades, is submerged in the stately beauty, the aura of mystery and the sense of organic life of the monument Pisani has created.

Pisani ingeniously manipulates scale for aesthetic ends and to create a complex and potent emotional aura. Thus, he places the tiny maquette of the island on the floor. Because of the model's size and its placement, the spectator seems to view it from a great distance and yet to apprehend it in all its immediacy. The surrounding blue is so concen-

trated that it creates an after-image which enhances the size of the work. Here and in other pieces, an object of almost miniature scale creates the illusion of monumentality and an aura of emotional grandeur. In certain works, such as the sofa from which tiny trees arise, Pisani confounds our perceptions by reversing normal proportional relationships. The powerful effects created alter both the space of the objects and the space of the viewer.

The commanding formal dimension of Pisani's work transmutes his theoretical musings into poetic metaphor. His extraordinary synthesis of fantasy and rational thought creates a compelling alternative reality. This reality is a magical world where architecture is theatre, where mythological characters and themes from past art take on a new and highly personal relevance, where a labyrinth of symbolic associations is revealed.

**Footnotes**

1. Thomas Bulfinch, *Bulfinch's Mythology,* Collier Books, New York, 1967, p. 155
2. Quoted in Edward Lucie-Smith, *Symbolist Art,* New York, 1972, p. 54
3. Arturo Schwartz, "The Alchemist Stripped Bare in the Bachelor, Even," in *Marcel Duchamp,* The Museum of Modern Art, New York, and Philadelphia Museum of Art, 1973, pp. 82-83
4. Bruno Corà, "Vettor Pisani: il coniglio non ama Joseph Beuys," *Domus,* no. 582, May 1978, p. 50

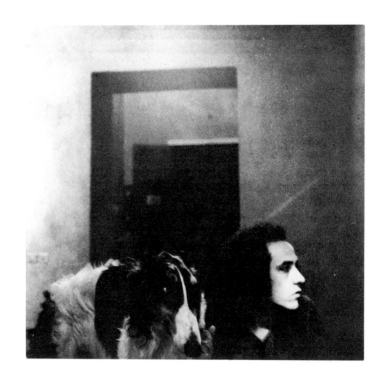

**69**
*Photograph of the Artist (Foto dell'artista)*

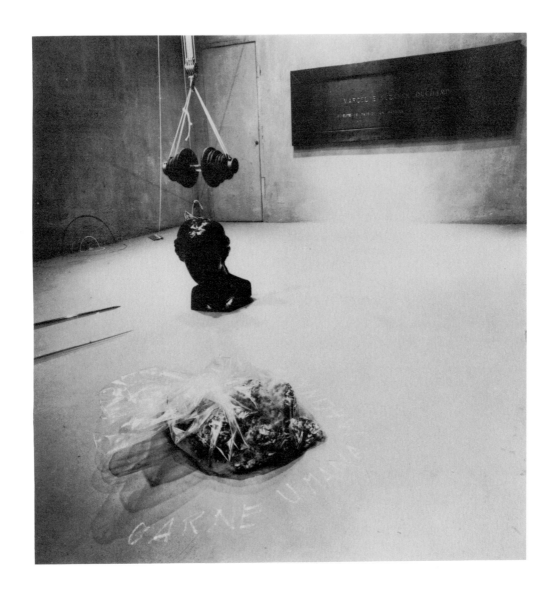

**70**
*The Hero's Room (Camera dell'eroe).* 1970

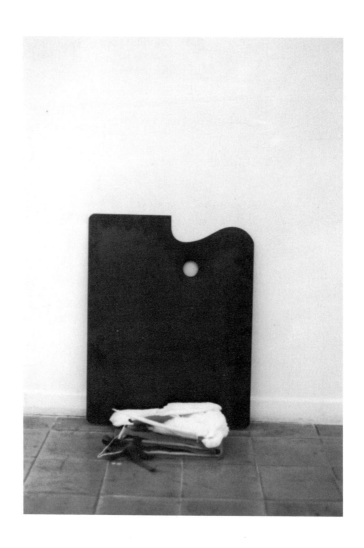

**71**
*Art Ends Where Nature Begins (L'arte finisce dove inizia la natura).* 1970

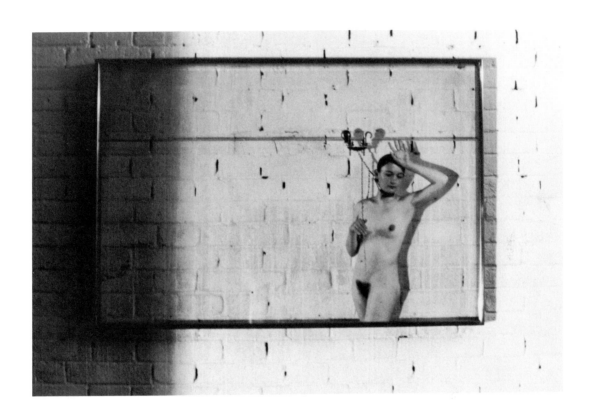

**72**
*Maria on the Runner, Elevation of the Virgin (La
Maria allo scorrevole, elevazione della Vergine).*
1972

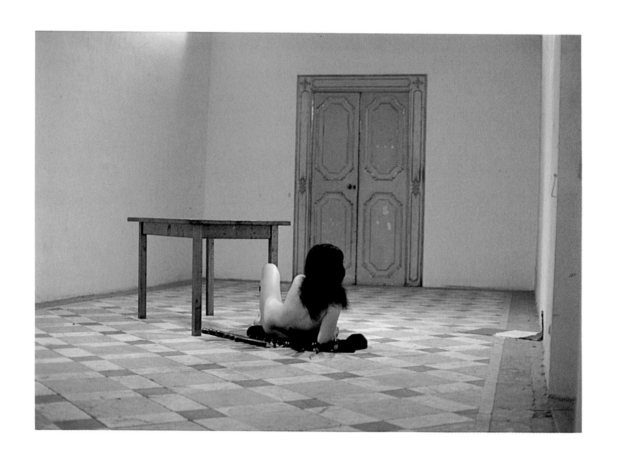

**73**
*Oedipus.* 1973

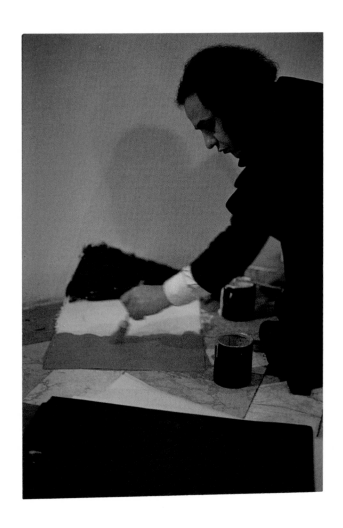

**74**
*Oedipus.* 1973

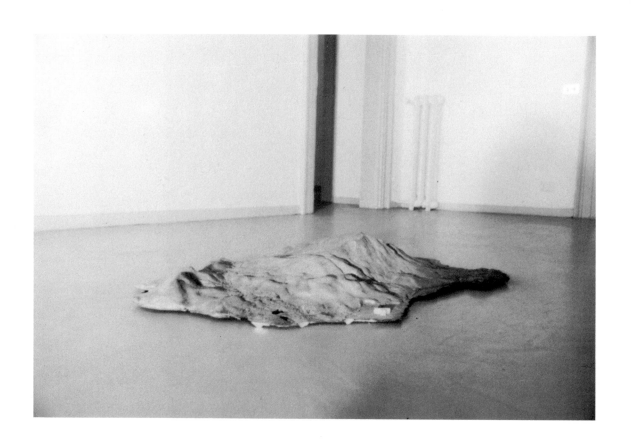

**75**
*R.C. Theatrum. Architecture on the Edge of a River, a Lake or the Sea (R.C. Theatrum. Architettura in riva a un fiume, a un lago, o al mare).* 1980

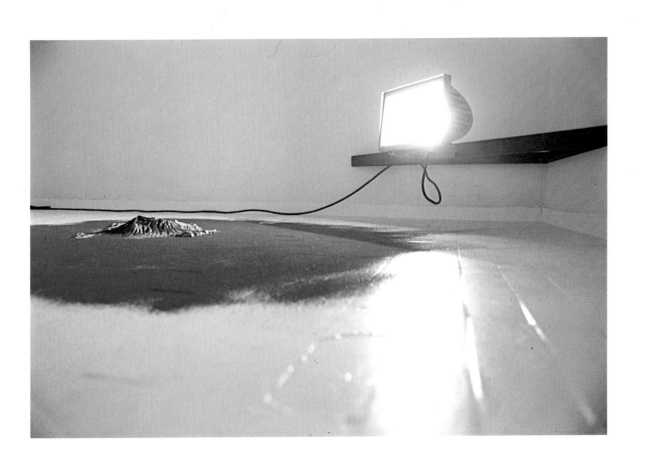

**76**
*Battle of Light and Dark (Lotta della luce e delle tenebre).* 1980

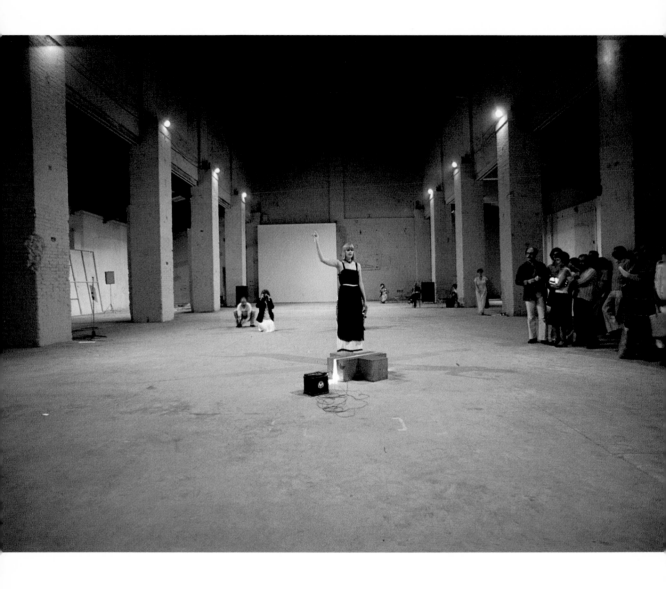

**77**
*The Theatre of the Rabbit (Il teatro del coniglio).*
1976
Recitation by Karla Koenig
Venice Biennale, 1976

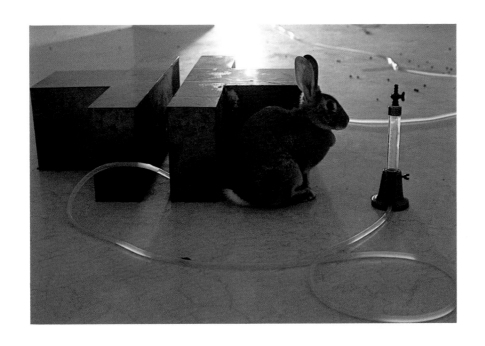

**78**
*The Theatre of the Rabbit (Il teatro del coniglio).*
1976
Venice Biennale, 1976

**79**
*The Artist Who Loves Nature (L'artista che ama la natura).* 1978

**80**
*East and West (Oriente e occidente).* 1975

**81**
*Oedipus and the Sphinx (Edipo e la Sfinge).* 1980
Cemetery of the Artists and Poets, Rome

**82**
*Labyrinth (Labirinto).* 1980

**83**
*The Cypresses on the Couch (I cipressi sul divano).*
1980

# Gilberto Zorio

Statement by the artist
*Dear Diane:*
*My works prefigure real projections of ideas which*
*promise to become concrete in images, images that*
*are stimulating and self-stimulated.*

*I am trying to join the components of potentiality,*
*of experiences, of energies, of desires, of expecta-*
*tions, which are reflected in queries.*

*The results are perhaps open and precarious*
*equilibriums, ignited by emphasis and by art.*

*With greetings, I remain,*
*Gilberto Zorio*

Born in Andorno Micca, 1944
Accademia di Belle Arti, Turin, degree 1970
Teaches at Liceo Artistico, Turin, 1968-present
Lives and works in Turin

Gilberto Zorio is a kind of modern-day alchemist. Though he does not change base materials into gold, he works with the most elemental and natural materials and transforms them into works of rare power and beauty. He makes visible fundamental elements, systems and forces of the phenomenological world. Perhaps most importantly, his acute sensitivity to the intrinsic qualities of his materials allows him to exploit the energies discharged by their interaction and to transmit these energies to the environment.

Zorio's present concerns grow out of his involvement with the *Arte Povera* (Poor Art) movement. In 1967 the critic Germano Celant coined the term *Arte Povera* to describe an essentially anarchic art created in reaction to the inexpressiveness of mass-produced consumer-oriented objects. In Celant's words, "It is a moment that tends towards deculturization, regression, primitiveness and repression, toward the pre-logical and pre-iconographic stage . . . a tendency towards the basic elements in nature . . . and in life . . . and in behavior. . . ."[1] The adherents of *Arte Povera* focused upon life and the natural processes: they shared in common an interest in primary elements and simple life forms— earth, fire, water, light, animals, vegetables and minerals. The artists explored these subjects not for illustrative or theoretical purposes, but to discover and extol their intrinsic, magical worth. In so doing, they broadened their knowledge of the world and, more importantly, rediscovered themselves. *Arte Povera* emphasized an anthropomorphic point of view and affirmed that in art the process rather than the product was primary.

Though Zorio moved beyond *Arte Povera* in the course of achieving his mature artistic identity, he retained a strong interest in energy, tension and process. In his words, "Energy is the possibility of filling emptiness, the possibility of emptying fullness, the possibility of planning past, present and future, the possibility of letting the known and unknown function of language become operative."[2] Thus the potential of energy lies at the crux of Zorio's expression. He conveys this energy through very direct presentation of materials and through the repeated use of a small number of constant images, materials and themes: the archetypal images of the star and the javelin (both energy equivalents), the materials metal, light, chemicals, animal hide, glass and terra-cotta, the theme of communication. By basing his compositions on the tenuous equilibrium of elements, he introduces extreme tension into his sculpture. And he creates situations or systems in which natural processes, usually physical or chemical reactions involving electricity, oxidation, evaporation or distillation, take place. These situations or systems in some instances operate autonomously, in others with the interference of the viewer. The incorporation of process brings the element of time into the pieces, which in turn lends them an anthropomorphic dimension: time passes as the process evolves, and the way the sculpture marks time is related to human experience. By often using extremely fragile materials in precarious situations, Zorio introduces a sense of the ephemeral into the work, a feeling of the possibility of change.

Zorio's various treatments of the recurrent motif of the star reveal these concerns. The star, created of the most fragile materials—crystal, terra-cotta, light —(cat. no. 90) works both as symbol and sign, is an energy system in itself and has an anthropomor-

phic meaning as it relates to man and his universe. In its different manifestations, Zorio's star may be a closed system impelled or sustained by its own internal laws, for example, the star of 1974 comprised of five metal javelins which stand alone, supported by their own stresses and counterstresses. Others, such as *Laser Star*, 1975, are dependent on external interference. The image in *Laser Star* exists only as a projection of light. The viewer becomes part of the system, allowing the star to take shape or causing it to disappear as his or her presence interrupts the laser beam. Through this participation the viewer is also incorporated into the work as an energy element. As Zorio has stated, ". . . in my work, energy is neither an abstract note nor something purely physical, but it implies a total human dimension, an anthropomorphic dimension. . . ."[3] He has sometimes used cobalt chloride, which causes the sculptures' surfaces to change color in response to atmospheric humidity. Again the human presence varies the system: the viewer's presence alters the work by causing a meteorological change. Thus Zorio establishes an interdependent relationship between his sculpture and the viewer: each affects the other.

In a more recent work entitled *Sifnos Stromboli,* 1981 (cat. no. 91), chloric acid and water are combined in a "crucible of fusion," a twisted, amphoralike form suspended in midair at the triangular junction of three metal poles which are anchored to the walls and floor. An elegant copper arc joins this crucible to a terra-cotta container on the floor which holds copper sulfate and water. Green salts from the acid in the crucible will coat one end of the arc, while the copper sulfate emulsion in the terra-cotta container will slowly cause blue crystals to form on the other end. The salt and crystals will ascend the arc over a period of time and eventually they will meet.

From 1968 through 1971 Zorio worked with words, exploring both the physical images of language and the less tangible implications of its meanings. Zorio executed several pieces entitled *Odio (Hate)*, a word fraught with emotional connotations. These works took the form of hatchet cuts made in gallery walls, writing in string hammered into lead ingot and a brand on the artist's forehead. Since the late sixties Zorio has also been making systems *For Purifying Words* (cat. nos. 84, 86-90, 92, 94), more abstract works which focus on processes of communication. In these works the viewer speaks into a funnel-shaped mouthpiece attached to a vessel containing alcohol; the words are filtered through the alcohol and emerge "metaphorically purified," cleansed of any ideological residue, to enter a free state. The dual nature of alcohol parallels the symbolic meaning of the works themselves: both purify and both are essences or spirits obtained by distillation.

Zorio intends his sculpture to operate on multiple levels. The purely formal, visual aspect of his sculpture is commanding and has an independent significance. Yet he also deliberately uses form, space and materials to reinforce thematic intent. Moreover, forms and materials are exploited for contradictory purposes; they are both seductive and menacing. The mellow patinae of surfaces, the gentle, seemingly organic swellings and variegated textures of terra-cotta mounds, the luster of animal hides are alluring and mesmerizing. Pleasing too are the gleam of his metal surfaces (often enhanced by spotlights which are part of the sculptures), the precarious suspension in space of the most fragile forms (a handblown pyrex beaker, for example, cat. nos. 88, 89) and the graceful, calligraphic drawing in space with metal. At the same time, bare electric wires, spikes or nails, javelins and finely honed metal rods suggest underlying primitivism and violence. Because it implies the release of energy and tension, violence is not only threatening but underscores the potential forces which are central to Zorio's oeuvre.

Zorio has always made beautiful drawings whose images are as fluid and elegant as the forms of his sculpture. In the past he has worked on wax, parchment and leather but most recently has been using engraving paper. Engraving paper is dense, thick and absorbent and these properties are particularly appropriate because Zorio draws with many of the highly textured, grainy materials of his sculpture—

such as volcanic ash from Stromboli, powdered copper mixed with varnish, acid and charcoal. Three separate pieces of paper comprise several of the drawings (for example, cat. nos. 92, 93); the image comes to life only when the papers are finally joined together. In this way the drawings are like the sculpture, which is often about disparate elements that ultimately become a unified whole. The angling of the three papers endows the finished drawing with a certain degree of three-dimensionality, a powerful dynamism and a lyrical grace. Zorio's drawings are not studies for sculpture but parallel the sculptures in the ideas they explore. There is a reciprocal relationship between the works in the two media—the drawings influence the sculptures and the sculptures influence the drawings.

Zorio uses space as a raw material: his sculptures create their own environments without being environmental. They reach out and attach themselves to the world. Zorio says, "I like to talk of fluid and elastic things, things without lateral and formal perimeters."[4] Perhaps Zorio's most impressive and moving achievement is his ability to convey extreme power with minimal means. The restrained use of form and the highly charged results which ensue endow the sculpture simultaneously with intensity and poetry. Reductive purism and simplicity propagate a new beauty and vitality which enlarge the traditional definition of sculpture and its communicative dimension.

### Footnotes

1. Celant, *Arte Povera*, 1969, p. 230
2. Trini, *Data*, 1973, p. 63
3. Luzern, one-man exh. cat., 1976, p. 72
4. Celant, *Arte Povera*, p. 185

### Selected Group Exhibitions

Galleria Sperone, Galleria Stein, Il Punto, Turin, *Contemplazione*, December 1967. Catalogue with text by Daniela Palazzoli

Università di Genova, *Arte Povera*, December 1967

Galleria de Foscherari, Bologna, *Arte Povera*, February 1968. Catalogue with texts by Renato Barilli and Germano Celant

Städtische Kunsthalle, Düsseldorf, *Prospect 68*, September 1968

Galleria RA3, Amalfi, *Rassegna d'arti figurative: Arte Povera—Azione Povere*, October 1968. Catalogue with texts by Giovanni M. Accame, Achille Bonito Oliva, Germano Celant, Gillo Dorfles, Piero Gilardi, Filiberto Menna and Tommaso Trini

Leo Castelli Warehouse, New York, *Nine at Castelli*, December 1968

Prague, *One hundred Works of Art from Futurism to Today*, December 1968. Traveled to Stockholm, Berlin and Rome

Kunsthalle Bern, *When Attitudes Become Form*, March–April 1969. Catalogue with texts by Scott Burton, Grégoire Müller, John A. Murphy, Harald Szeemann and Tommaso Trini

The Solomon R. Guggenheim Museum, New York, *Nine Young Artists: Theodoron Awards*, May 24–June 29, 1969. Catalogue with texts by Edward F. Fry and Diane Waldman

Museum Folkwang, Essen, *Verbogene Strukturen*, May–June 1969

Galleria Sperone, Turin, *Mostra collettiva*, October–November 1969

Galleria d'Arte Moderna, Bologna, *3° Biennale della giovane pittura*, January–February 1970

Tokyo Metropolitan Art Gallery, *Biennial '70*, May 1970. Traveled to Kyoto Municipal Art Museum; Aichi Prefectural Art Gallery, Nagoya; Fukuoka Prefectural Culture House

Kunstmuseum Luzern, *Processi di pensiero visualizzati: Junge italienische avantgarde*, May–July 1970. Catalogue with texts by Jean-Christophe Ammann and Germano Celant

Galleria Civica d'Arte Moderna, Turin, *Conceptual Art, Arte Povera, Land Art*, June–July 1970. Catalogue with texts by Germano Celant, Lucy Lippard and A. Passoni

Palazzo delle Esposizioni, Rome, *Vitalità del negativo nell'arte italiana 1960-1970*, November 1970–January 1971. Catalogue with texts by Giulio Carlo Argan, Alberto Boatto, Achille Bonito Oliva, Maurizio Calvesi, Gillo Dorfles, Filiberto Menna and C. Vivaldi

Kunstverein München, Munich, *Arte Povera: 13 italienische Künstler*, May–June 1971. Catalogue with text by Germano Celant

Parc Floral de Paris, Bois de Vincennes, *Septième Biennale de Paris: Manifestation biennale et internationale des jeunes artistes*, September–November 1971. Catalogue with text by Achille Bonito Oliva

Museo de Arte Moderno de la Ciudad de Buenos Aires, *Arte de Sistema*, October 1971. Catalogue with text by J. Glusberg

John Weber Gallery, New York, *De Europa*, April 1972

San Nicolò, Spoleto, *420 West Broadway et Spoleto Festival*, June 1972

Museum Fridericianum, Kassel, Germany, *Documenta V*, June–October 1972. Catalogue

Galerie MTL, Brussels, *Huit Italiens / Acht Italienen*, January–February 1973. Traveled to Art and Project, Amsterdam

The Arts Council of Northern Ireland Gallery, Belfast, *An Exhibition of New Italian Art*, November 1973. Traveled to The David Hendricks Gallery, Dublin

Kunsthalle Köln, Cologne, *Projekt '74, Kunst bleibt Kunst: Aspekte internationaler Kunst am Anfang der 70er Jahre*, July–September 1974. Catalogue with texts by M. Grüterich, W. Herzongenrath, D. Ronte, M. Schneckenburger, A. Schug and E. Weiss

Städtische Kunsthalle, Düsseldorf, *Prospectretrospect, Europa 1946-1976*, October 1976

Galleria Civica d'Arte Moderna, Turin, *Arte in Italia 1960-1977*, May–September 1977. Catalogue with texts by Francesca Alinovi, Renato Barilli, Antonio Del Guercio and Filiberto Menna

The Art Institute of Chicago, *Europe in the Seventies: Aspects of Recent Art*, September–October 1977. Traveled to The Hirshhorn Museum and Sculpture Garden, Smithsonian Institution, Washington, D.C.; San Francisco Museum of Modern Art; Fort Worth Art Museum; Contemporary Arts Center, Cincinnati

Venice, *La Biennale di Venezia: Dalla natura all'arte, dall'arte alla natura*, June 1978. Catalogue with texts by Jean-Christophe Ammann, Achille Bonito Oliva, Antonio Del Guercio and Filiberto Menna

Castello Colonna, Genazzano, *Le Stanze*, November 1979. Catalogue with text by Achille Bonito Oliva

Halle für internationale neue Kunst, Zürich, *Luciano Fabro / Wolfgang Laib / Gerhard Merz / Gilberto Zorio*, March 1980

Venice, *La Biennale di Venezia: Aperto '80, Art in the Seventies*, June 1980. Catalogue with texts by Achille Bonito Oliva, Michael Compton, Martin Kunz and Harald Szeemann

Museum Van Hedendaagse Kunst, Gand, *Kunst in Europa na '68*, June–August 1980. Traveled to Centrum voor Kunst en Cultuur, St.-Pietersplein. Catalogue with texts by Germano Celant, Johannes Cladders, Piet Van Daalen, Rita Dubois, Karel J. Geirlandt, Jan Hoet, Sandy Nairne and Jean Pierre Van Tieghem

Galerie Walter Storms, Munich, Villingen, December 1980. Catalogue with text by Walter Storms

Galleria Sperone, Turin, January 1981

Musée National d'Art Moderne, Centre d'Art et de Culture Georges Pompidou, Paris, *Identité italienne: l'art en Italie depuis 1959*, June–September 1981. Catalogue with text by Germano Celant

Galerie Walter Storms, Munich, April 1982

**Selected One-Man Exhibitions**

Galleria Sperone, Turin, November 1967. Catalogue with text by Tommaso Trini; February 1969; May 1971; December 1973; January 1974; November 1974

Centro Colautti, Salerno, May 1968. Catalogue with text by Alberto Boatto

Galerie Sonnabend, Paris, February 1969

Galleria Toselli, Milan, May 1970; May 1974

Galleria Flori, Florence, March 1971

Modern Art Agency, Naples, June–July 1971

Incontri Internazionali d'Arte, Palazzo Taverna, Rome, December 1971

Galerie MTL, Brussels, December 1973

Galleria dell'Ariete, Milan, October 1975

Kunstmuseum Luzern, *Gilberto Zorio*, May–June 1976. Catalogue with texts by Jean-Christophe Ammann, Ugo Castagnotto and Werner Lippert

Galleria Schema, Florence, October 1976

Studio De Ambrogi / Cavellini, Milan, December 1976

Galleria Del Tritone, Biella, January 1977; April 1978

Studio G7, Bologna, March 1977; April 1980

Studio Cesare Manzo, Pescara, December 1977

Piero Cavellini, Brescia, January 1978

Galerie Albert Baronian, Brussels, February 1978; 1980

Galerie Eric Fabre, Paris, February 1978; 1980

Galerie 't Venster, Rotterdam, March 1978

Carlo Grossetti Studio, Milan, April 1978

Piero Cavellini, Milan, April 1978

Salone Annunciata, Milan, April 1978

Galleria Christian Stein, Turin, February 1979

Jean & Karen Bernier, Athens, February 1979; November 1980

Stedelijk Museum, Amsterdam, *Gilberto Zorio,* March–May 1979. Catalogue with text by Jean-Christophe Ammann

Emilio Mazzoli, Modena, September 1979

Galleria De Crescenzo, Rome, February 1980

Galleria Salvatore Ala, Milan, February 1981

Galerie Meyer-Hahn, Düsseldorf, May 1981

Galerie Rudiger Schöttle, Munich, July 1981

Sonnabend Gallery, New York, October 1981

Galerie Appel und Furtsch, Frankfurt, November–December 1981. Catalogue with text by Werner Lippert

### Selected Bibliography

BY THE ARTIST

"Gilberto Zorio," *Extra,* no. 5, July 1975, pp. 32-44

"Gilberto Zorio," *Data,* no. 32, Summer 1978, p. 30

ON THE ARTIST

*Newspapers and Periodicals*

Tommaso Trini, "La scuola di Torino," *Domus,* no. 457, December 1967, p. 69

Ed Sommer, "Prospect 68 and Kunstmarkt 68," *Art International,* vol. 13, February 1968, p. 32

Piero Gilardi, "Primary Energy and the 'Micro-emotive Artists,' " *Arts Magazine,* vol. 43, September–October 1968, pp. 48-52

Tommaso Trini, "Nuovo alfabeto per corpo e materia," *Domus,* no. 470, January 1969, p. 47

Emily Wasserman, "Theodoron Awards," *Artforum,* vol. 8, September 1969, p. 58

Germano Celant, "48 Page Exhibition," *Studio,* no. 180, July 1970, p. 16

A. Henze, "Vitalità del negativo nell'arte italiana 1960-1970: Palazzo delle Esposizioni, Rom," *Das Kunstwerk,* no. 2, March 14, 1971, pp. 87-88, 91, 107

Gillo Dorfles, "Una mostra romana: Vitalità del negativo nell'arte italiana," *Art International,* vol. 15, April 1971, pp. 15-18

Jole de Sanna, "Gilberto Zorio: corpo di energia" *Data,* vol. 2, April 1972, pp. 16-23

Tommaso Trini, "Anselmo, Penone, Zorio e le nuove fonti d'energia per il deserto dell'arte," *Data,* no. 9, Autumn 1973, pp. 62-67

Mirella Bandini, "La stella di Zorio," *Data,* no. 24, December 1976, pp. 48-51

Roberto Daolio, "Energia in forma di Stella," *G 7 Studio,* vol. II, March 1977, pp. 4-7

Achille Bonito Oliva, "Process, Concept and Behaviour in Italian Art," *Studio International,* no. 191, January–February 1976, pp. 3-11

Jan van der Marck, "Inside Europe Outside Europe," *Artforum,* vol. 16, January 1978, pp. 48-55

Corinna Ferrari, "Stanze del Castello," *Domus,* no. 604, March 1980, p. 55

Luciana Rogozinski, "Gilberto Zorio," *G 7 Studio,* vol. V, March 1980, pp. 4-7

Laura Cherubini, "The Rooms: Castello Colonna/Genazzano," *Flash Art,* no. 96-97, March–April 1980, pp. 42-43

R. G. Lambarelli, "Gilberto Zorio," *Segno,* no. 15, March–April 1980, p. 24

Bernard Marcelis, "I muri di Gent: 'Kunst in Europa na '68,' " *Domus,* no. 609, September 1980, p. 48

Renato Barilli, *Espresso,* no. 12, March 29, 1981, p. 99

Flaminio Gualdoni, "Gilberto Zorio," *G 7 Studio,* vol. VI, June 1981, pp. 4-5

Luciana Rogozinski, "Gilberto Zorio: Galleria Ala, Milan," *Artforum,* vol. 19, Summer 1981, p. 102

Ross Skoggard, "Gilberto Zorio at Sonnabend," *Art in America,* no. 10, December 1981, p. 143

*Books*

Germano Celant, *Arte Povera,* Milan, 1969

Achille Bonito Oliva, *Europa/America,* Milan, 1976, p. 298

Maurizio Calvesi, *Avanguardia di massa,* Milan, 1978

*Schema informazione, Politic-art,* Galleria Schema, Florence, 1978

**84**
*To Purify Words (Per purificare le parole).* 1978
Terra-cotta, metal spears, lamp and alcohol,
82½ x 51 x 19½ ″ (210 x 130 x 50 cm.)
Collection Stedelijk Museum, Amsterdam

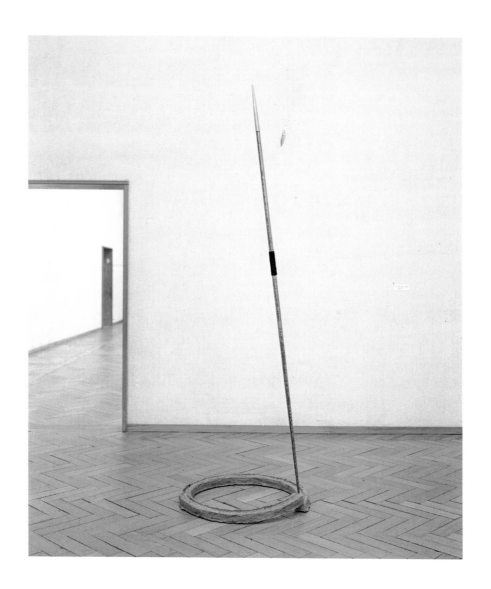

**85**
*Circle and Spear (Cerchio e giavellotto).* 1978
Terra-cotta with metal spear, 102¼ x 35″ (260 x
89 cm.)
Collection Albert Baronian, Brussels

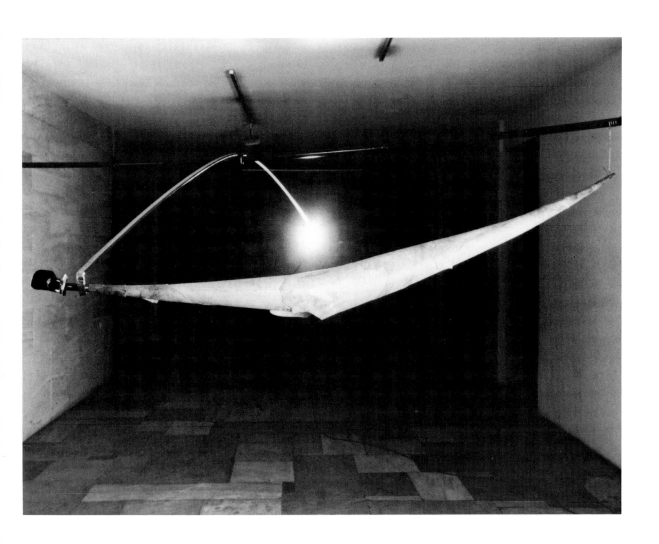

**86**
*To Purify Words (Per purificare le parole).* 1979
Parchment, copper balance, electric light bulb and
alcohol, 236 x 169 x 86½ ″ (600 x 430 x 220 cm.)
Courtesy Karen & Jean Bernier, Athens

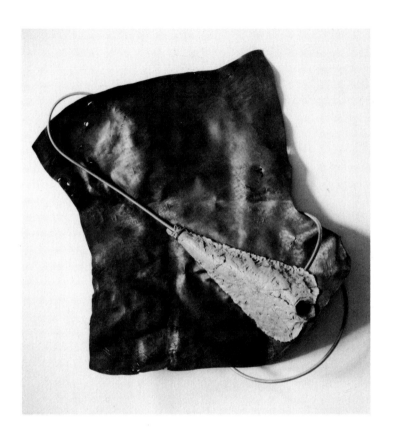

**87**

*To Purify Words (Per purificare le parole).* 1980
Terra-cotta, leather, metal tube and alcohol,
81½ x 71 x 15¾″ (210 x 180 x 40 cm.)
Collection of the artist

**88**

*To Purify Words (Per purificare le parole).* 1980
Leather, iron rod, pyrex container and alcohol,
204¾ x 157½″ (520 x 400 cm.)
Courtesy Galleria Salvatore Ala, Milan

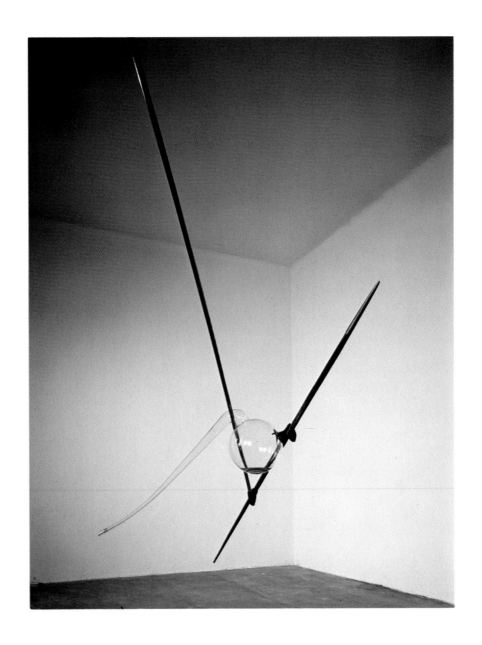

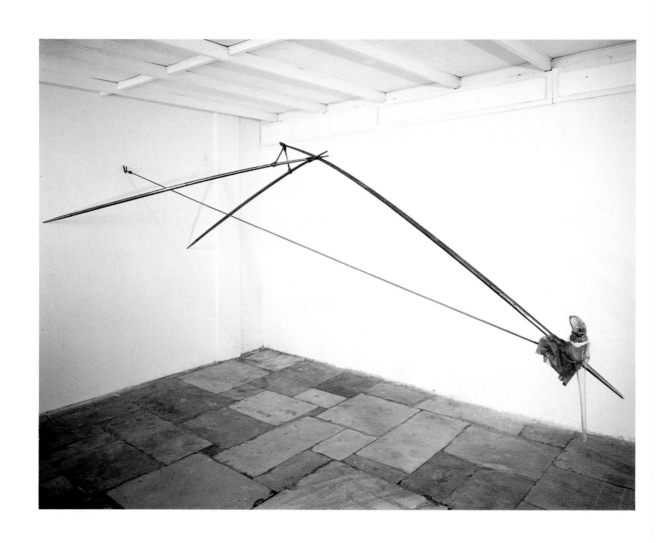

**89**
*To Purify Words (Per purificare le parole).* 1980
Metal spears, leather and pyrex container,
165¼ x 86¾ x 71″ (420 x 220 x 180 cm.)
Courtesy Karen & Jean Bernier, Athens

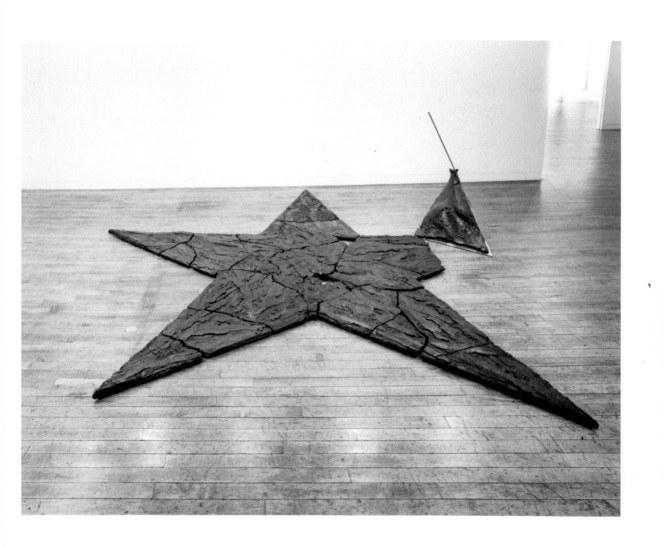

**90**

*Star (To Purify Words) (Stella [per purificare le parole]).* 1980
Terra-cotta and metal, 195″ (495 cm.) d.
Courtesy Sonnabend Gallery, New York

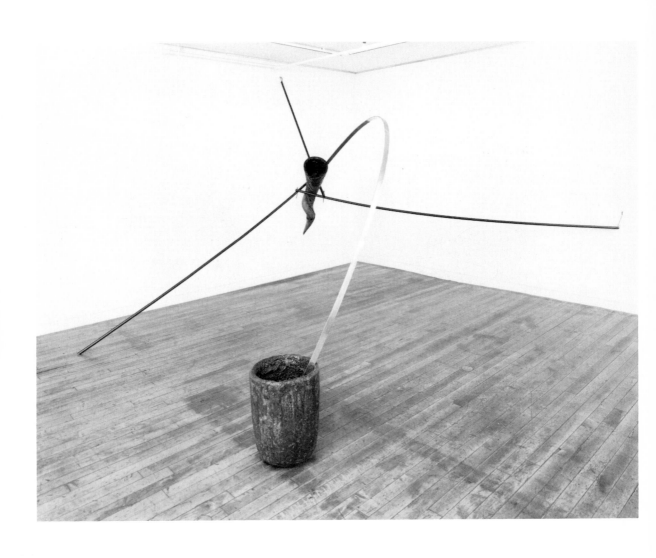

**91**
*Sifnos Stromboli.* 1981
Terra-cotta, copper, iron and chloric acid,
196¾ x 216½ ″ (500 x 550 cm.)
Courtesy Sonnabend Gallery, New York

**92**
*To Purify Words (Per purificare le parole).* 1981
Volcanic ash from Stromboli, varnish and charcoal
on engraving paper, ca. 64¾ x 67¾ " (165 x 172 cm.)
Collection of the artist

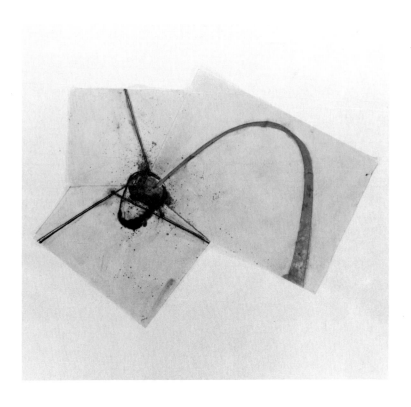

**93**
*Melting Pot (Crogiuolo).* 1981
Ink, ash, charcoal and copper varnish on engraving
paper, ca. 50¼ x 74″ (127.5 x 187.9 cm.)
Collection of the artist

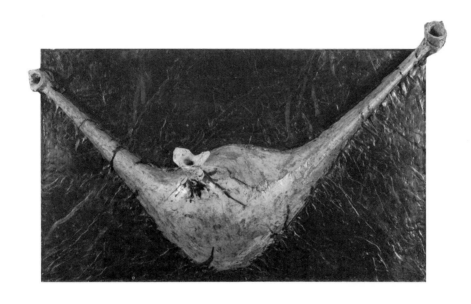

**94**

*To Purify Words (Per purificare le parole).* 1981
Terra-cotta, wax and alcohol,
26 x 45 x 9″ (66 x 114 x 22.8 cm.)
Courtesy Sonnabend Gallery, New York

# Photographic Credits

**Exhibition 82/2**

5,000 copies of this catalogue, designed by
Malcolm Grear Designers, typeset by
Dumar Typesetting, Inc., have been printed by
Eastern Press in March 1982 for
the Trustees of The Solomon R. Guggenheim
Foundation on the occasion of
**Italian Art Now: An American Perspective,**
**1982 Exxon International Exhibition**